PHOTOSHOP

The Latest Artwork & Techniques From The World's Top Digital Artists

Edited by AGOSTO

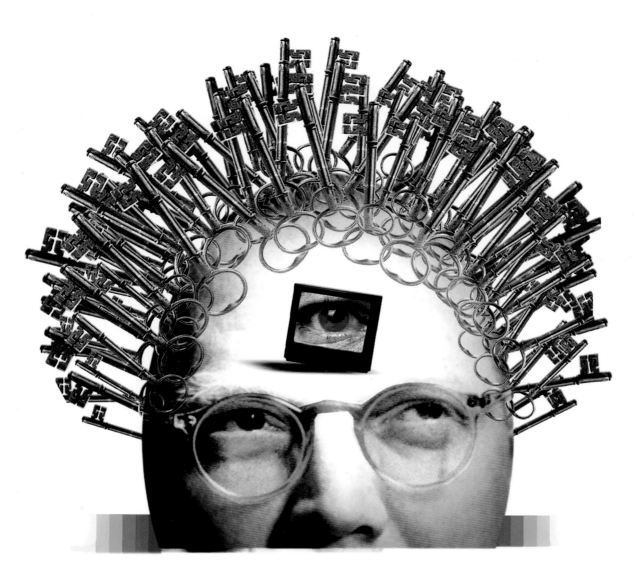

Rockport Publishers, Inc. Gloucester, Massachusetts

Copyright © 1998 by AGOSTO Inc.

All rights reserved. No part of this book may be reproduced in any form without written permission of the copyright owners. All images in this book have been reproduced with the knowledge and prior consent of the artists concerned and no responsibility is accepted by producer, publisher, or printer for any infringement of copyright or otherwise, arising from the contents of this publication. Every effort has been made to ensure that credits accurately comply with information supplied.

First Japanese edition by Graphic-sha Publishing Co., Ltd.
Tokyo, Japan

First English edition published in the United States of America by:
Rockport Publishers, Inc.
33 Commercial Street
Gloucester, Massachusetts 01930-5089
Telephone: (978) 282-9590
Facsimile: (978) 283-2742

Distributed to the book trade and art trade in the United States by:
North Light Books, an imprint of
F & W Publications
1507 Dana Avenue
Cincinnati, Ohio 45207
Telephone: (800) 289-0963

Other Distribution by:
Rockport Publishers, Inc.
Gloucester, Massachusetts 01930-5089

ISBN 1-56496-502-3

10 9 8 7 6 5 4 3 2 1

Manufactured in Hong Kong.

Foreword

I have been chosen to write the foreword for this book because I'm a time traveler from the past and I've seen the future. The future actually gets clearer as you travel farther back in time. That may sound strange, but it's true. If you've seen design history changing as much as I have, then you know that the future is going to be more of the same. Working at Adobe for the past twelve years, I've seen our design tools change so dramatically that it really seems like I'm traveling at the speed of light.

Imagine not having Adobe Photoshop! Can you think of anything more scary? I know what it was like. I actually wrote PostScript code directly in the early days to get graphics onto paper. I know the pain of using press down type and screening images in the darkroom. What a pleasure to know that press down type has gone away, never to return.

So, where are things headed today? What is clear to me is that, as designers and illustrators, we now have more choices than ever before. In the beginning (only ten years ago by my clock) computers gave us too many choices and we were lulled into a false "design euphoria." The computer in combination with high quality printing made a bad design or illustration seem so clean and clear that it just had to be good. We would stop the design process, leaving us with a less than perfect solution. Fortunately, and this book is proof, designers' control over these new tools has blossomed and we are no longer slaves to our computers. Designers can now see beyond the easy solutions that the computer brings and look to the best possible design solutions.

What you will see in this book are great people doing some incredible work. I think what makes this book unique is the way it shares information, bringing to the reader the techniques and personal innovations of each of the artists included. I love it! It's like a community of design. Everyone seems to have a distinct way of thinking when they work with Adobe Photoshop. I'm continually amazed at the number of unique techniques and styles of illustration that are emerging. I get energized, and ready to start a new illustration or design of my own after looking at a book like this. It's one of those books you can come back to again and again, as a valuable resource of visual information. It's like an encyclopedia of good ideas.

Russell Preston Brown
Senior Creative Art Director,
Adobe Systems Inc.

Contents

Lou Beach

Lou Beach has been a freelance graphic designer for over 20 years. He has done work for a variety of publications including *BusinessWeek*, *The New York Times*, *Wired* and *Harper's* magazine. As a founding partner and the creative director at ION, he worked with musicians David Bowie and Brian Eno, creating interactive CD-ROMs. He has also taught editorial illustration at The Art Center in Pasadena and at Otis Parsons in Los Angeles. Born in 1947 to Polish parents, he emigrated to the United States in 1951. After his third year of college in Buffalo, he decided to drop out and traveled to California, where he began his career as an artist making collages and studying Surrealist art. Over the years he has traveled extensively and taken on a variety of jobs such as truck driver and janitor to support his career as an artist. He currently lives in Los Angeles with his wife and two children.

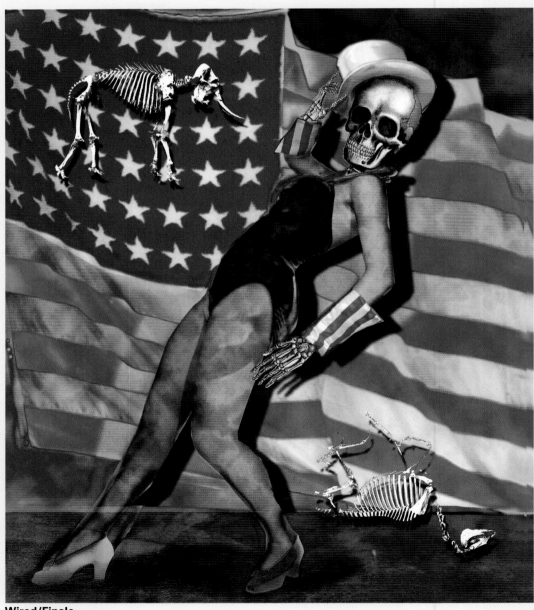

Wired/Finale
Wired: Editorial illustration

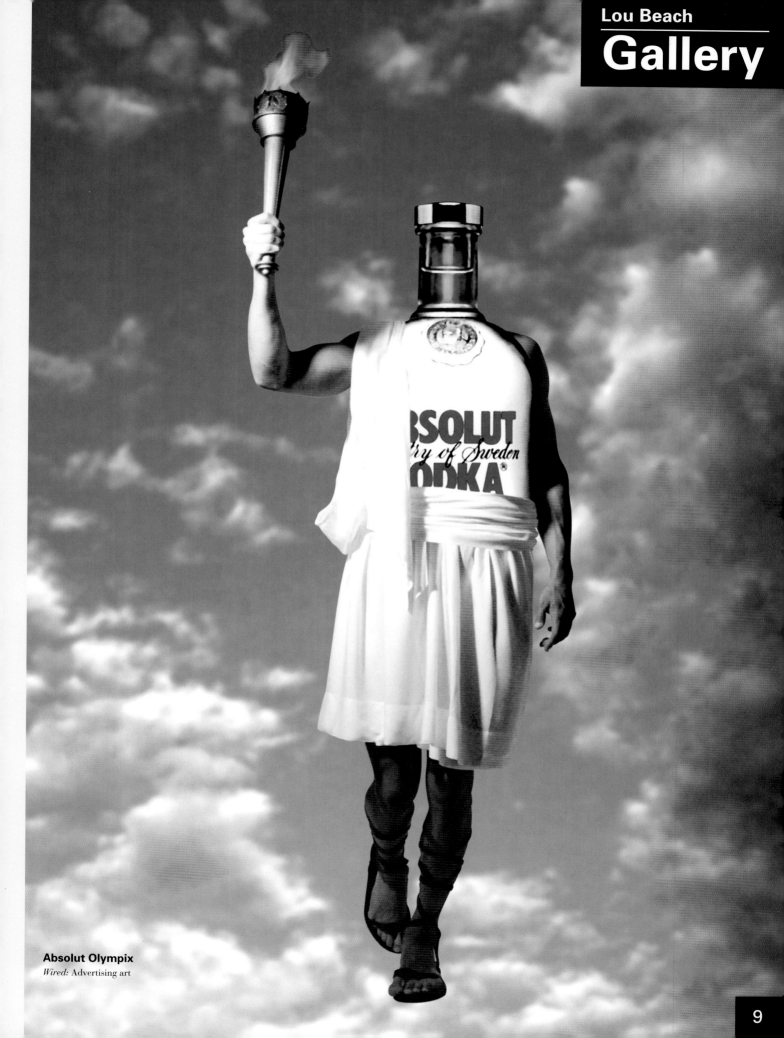

Absolut Olympix
Wired: Advertising art

Pollster
The New York Times Magazine: Editorial illustration

Village Voice
The Village Voice: Magazine cover

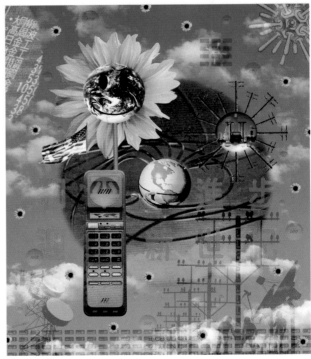

Future Poster
Wired: Editorial illustration

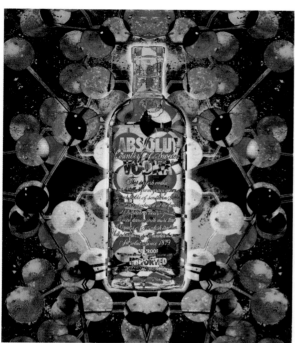

Absolut Lou Beach
Wired: Advertising art

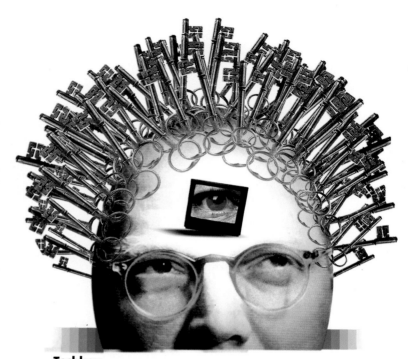

Techkey
The New Yorker: Editorial illustration

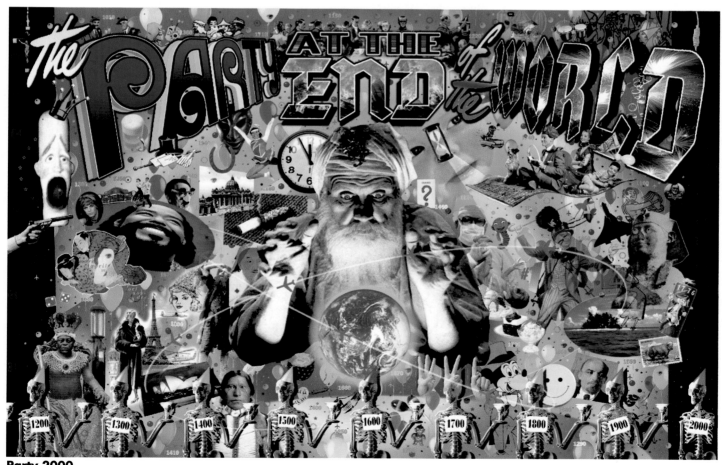

Party 2000
Los Angeles Magazine: Editorial illustration

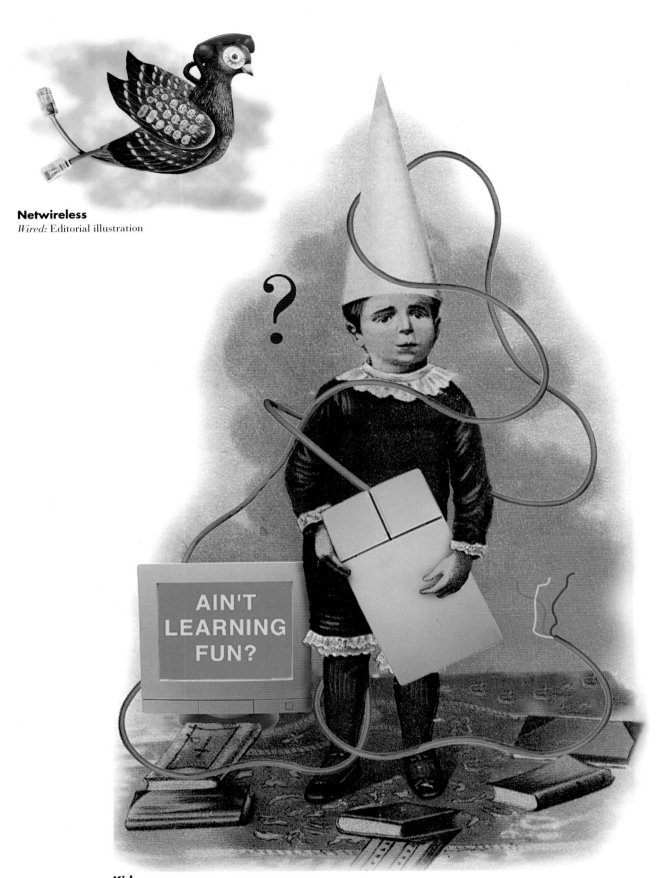

Netwireless
Wired: Editorial illustration

AIN'T LEARNING FUN?

Kid
The Los Angeles Times: Editorial illustration

Drugasaurus
The New York Times Magazine:
Editorial illustration

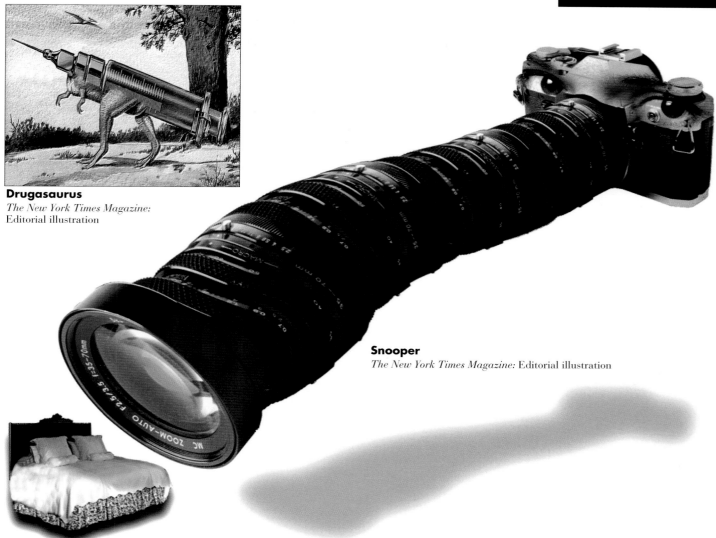

Snooper
The New York Times Magazine: Editorial illustration

Responding to Literature
Original artwork

Pat Buchanan
Wired: Editorial illustration

Big Fish, Little Fish

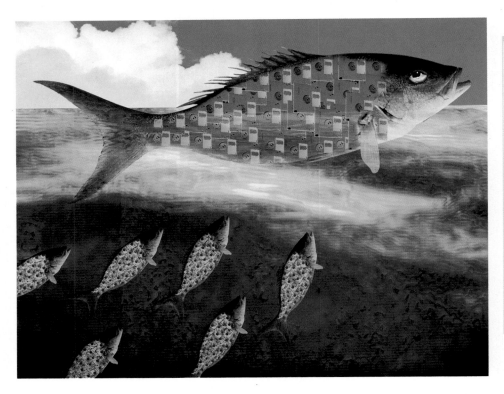

Assignment

Create an illustration for *BusinessWeek* magazine as part of a series of illustrations to be featured in a special issue about Silicon Valley. This particular illustration was meant to convey the idea that although there are several major cities with business areas specializing in the computer industry, they are often overshadowed by the immense influence of Silicon Valley. Thus, while each area is comprised of successful enterprises in their own right, collectively they are the "little fish" following the lead of the "big fish."

Step 1

First I determined the image size and resolution of the Silicon Fish document and then selected RGB mode. Although the final piece was to be in CMYK, working in RGB reduced the file size and allowed me to use certain filters that generally do not work in CMYK. However, I usually turn on CMYK Preview in the View menu to give me a better idea of what the final colors will look like (see fig. 1).

New

Name: Silicon Fish

Image Size: 10.2M

Width: 8 inches

Height: 6.312 inches

Resolution: 266 pixels/inch

Mode: RGB Color

OK Cancel

Contents
- ● White
- ○ Background Color
- ○ Transparent

❶

Step 2

From MetaTool's *MetaPhoto* series, I found a suitable fish image that I used as the main subject of my illustration. For this project, the hi-res version of the image was chosen. Since the image already had a path included, the path of the image was selected from the Paths palette in *Photoshop* and dragged into my current document (see fig. 2-A). I then chose the Free Transform command from the Layers menu. Holding down the Shift key to maintain the proportions of the image, I sized the fish down and rotated it slightly (see fig. 2-B).

❷-A

Step 3

In keeping with the other illustrations, which included images referring to computer technology, I decided that the fish would have scales consisting of floppy disks. An orange floppy disk image was taken from PhotoDisc's *Royalty Free Digital Stock* series collection. Again, I went to the Paths palette, clicked on the path, and dragged it into my document (see fig. 3-A). After resizing and rotating the disk image using the Free Transform command, I made a rectangular selection around the image and copied it several times. Multiple copies of the floppy were then pasted over the fish to make the "scales." Since each pasted floppy disk image creates its own layer, I decided to merge the separate layers to keep the file size manageable. After adjusting disk layers that seemed out of place, I clicked on the eye icons in the Layers palette of the layers I did not want to merge (the fish and the background layers), which hid them from view. Then the separate disk layers were merged by selecting Merge Visible from the Layers palette (see fig. 3-B).

❷-B

❸-A

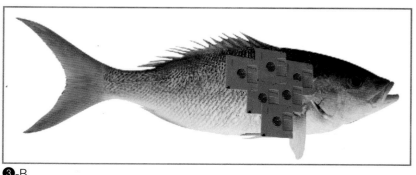

❸-B

Step 4

After making the other layers visible again I reduced the opacity of the floppy disk layer so that the fish underneath could be seen. From the Brushes palette, I selected a large, soft-edged brush shape and chose the airbrush tool with the pressure set to about 50%. I "erased" the edges of the floppy layer by airbrushing the edges in white until the layer conformed to the shape of the fish (see fig. 4).

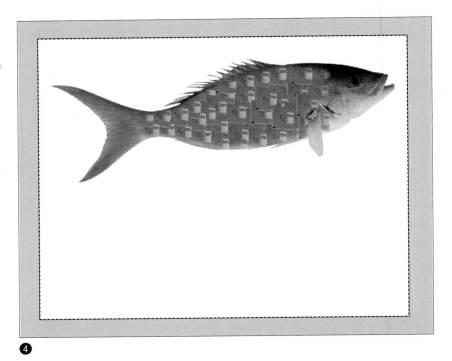

4

Step 5

Now that I've created the "big" fish, it's time to make the "little" fish that follow. First the floppy and fish layers were merged and the resulting layer was duplicated. Next, the duplicate fish was scaled down to "little" size. After selecting the Color Range command, the orange color of the floppy disk was sampled using the eyedropper tool. Then I went to the Image menu and chose Adjust > Hue/Saturation. Moving the Hue slider, the color of the scales was changed from orange to yellow (see fig. 5-A). More "little" fish were created using the Duplicate Layer command. After rotating each "little" fish and placing them below and to the left of our "big" fish, I was now satisfied with the overall composition of the illustration (see fig. 5-B).

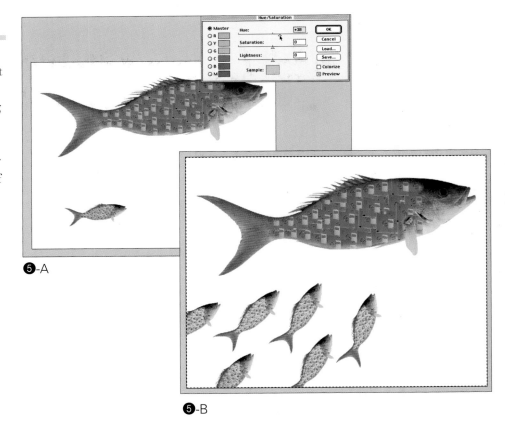

5-A

5-B

Step 6

After selecting an ocean photo from the *MetaPhoto* series, the image was dragged into the composition behind the fish and then flipped horizontally with the top portion of the image trimmed off. The opacity of the layer was reduced to about 80%. Water in front of the fish was created by duplicating the original water layer and placing the duplicate in front of the fish layers. After bringing up the Hue/Saturation dialogue box, I checked the Colorize button and gave the foreground water a greenish cast. Then the opacity was reduced to about 30% and the entire layer was moved so that it was slightly offset from the background water layer (see fig. 6-A and 6-B).

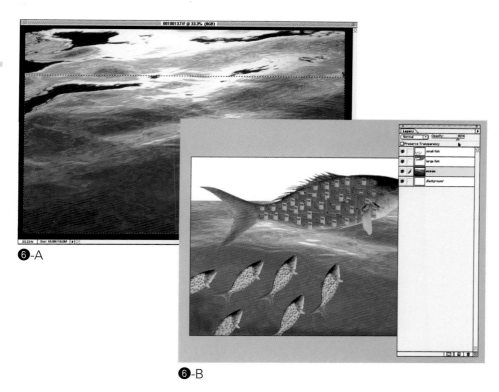

❻-A

❻-B

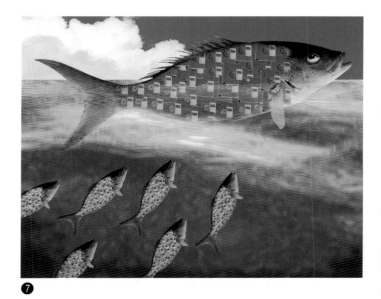

❼

Step 7

A photo of clouds and sky that I took was dragged into the composition, sized and cut to fit into the area above the water. A good human eye image was then pasted into our "big" fish, making it stand out and become visually even more important than its lesser compatriots. The image was softened and the edges of the eye erased. Finally, before sending it off to the client, I merged all the layers and converted the file to CMYK. Then I adjusted the color with Image > Adjust > Curves and sharpened the image using the Unsharp Mask filter (see fig. 7).

Ako Nakamura

After working for eight years as a graphic designer in Japan, Nakamura came to the United States in 1988 to pursue a graduate degree at the Yale University School of Art and Architecture. After graduating, she worked on a variety of publications, including a book by Paul Rand called *Design, Form, and Chaos*. In addition to her work for corporations such as NTT, Adobe Systems and Fuji Film, she was also a grant recipient from the Rockefeller Foundation and the French Ministry of Culture. While in France, she worked as the art director for the Butoh Dance Theatre in Marseilles and Toulon. She has also taught graphic design and has been a speaker at MacWorld Tokyo and at the NTT Media Lab. She now runs her own digital art and design firm from her studio in the Santa Cruz Mountains called *mach9* and currently lives in the Bay Area with her husband, two cats and a chameleon.

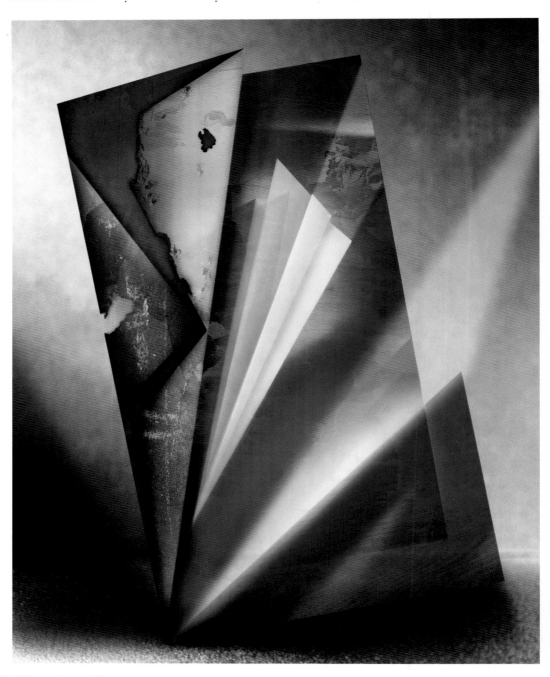

Origami
Original work

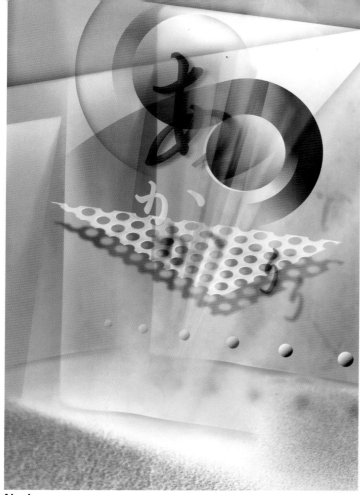

Akari
Original work
Software: Illustrator

Chinese PageMaker
Adobe Systems: Campaign Advertising Poster
Software: Ilustrator, PageMaker

Japanese Typography Ad
Adobe Systems: Advertisement for Japan Typography Annual
Software: Illustrator

Target
MetaCreations: Poster for Japan Digital Art Contest
Software: Painter, Bryce

Ice & Fire
French Ministry of Culture: Butoh Dance Stage
Software: Premiere

Goblins from the Land of Ice
French Ministry of Culture: Butoh Dance Stage

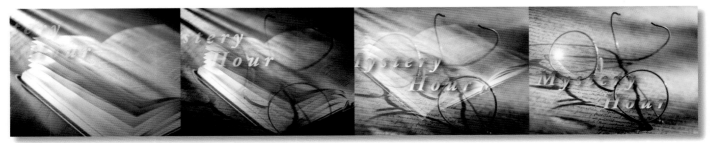

Mystery
Original work

Package Design with Japanese Flavor

Assignment

Create a new illustration to be used on the packaging of *Adobe Value Pack*, a font package that includes ten kinds of European fonts and two kinds of Japanese fonts. For the background image I decided on traditional Japanese paper, which was hand-dyed with colored ink. I also decided that the two Japanese fonts would be displayed in the foreground in three-dimensional space using highlights and shadows, layered through several alpha channels.

Fonts Package
Adobe Systems: Package design
Software: Illustrator

Step 1

First, the traditional Japanese paper was scanned into Photoshop as a grayscale image and then converted into a duotone image in black and orange by selecting Image > Mode > Duotone. In the Duotone Options dialog box, I clicked the duotone curve boxes and adjusted the tone curves until the desired colors were created (see fig. 1-A and 1-B).

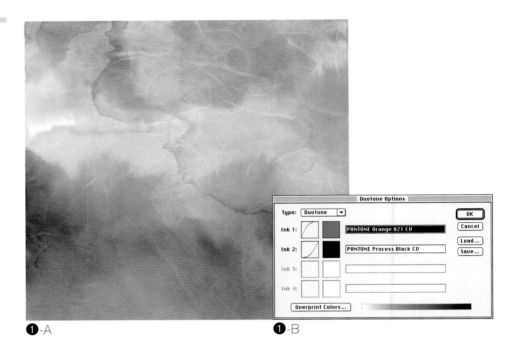

❶-A ❶-B

Step 2

I then converted the image from duotone mode to RGB mode. To maintain the visual balance of the composition, the orange background color was adjusted by selecting Image > Adjust > Variations (see fig. 2-A and 2-B).

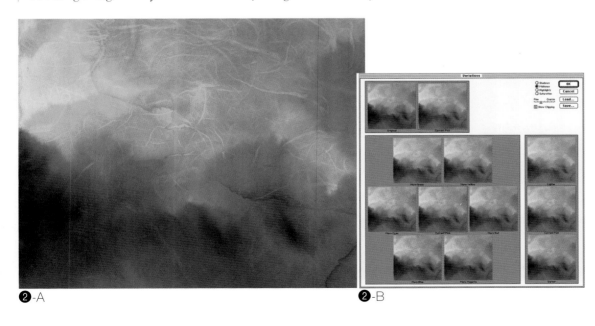

❷-A ❷-B

Step 3

The main Japanese font image "永" along with the other font images to be used for the composition were created and laid-out in *Illustrator* and then imported into *Photoshop* as a separate layer so that the transparency of the images could be adjusted using alpha channels (see fig. 3-A and 3-B).

❸-A ❸-B

Step 4

I created five different masks using alpha channels and used Levels to create relief, generating the appearance of three-dimensionality in the main font image. The channels were named 'Original', 'Fat', 'Emboss/Highlight', 'Shadow' and 'Interior Shadow'. From the Layers palette, 'Original' was selected. I created the 'Fat' channel by dragging and dropping the 'Original' channel onto the duplication icon at the bottom of the Layers palette. In the 'Fat' channel, I "fattened" the image by using the Maximum filter which increased the radius of the pixels in the image. Then a negative of the "fattened" image was created by choosing the Invert command (see fig. 4-A through 4-C).

❹-A #4 Original

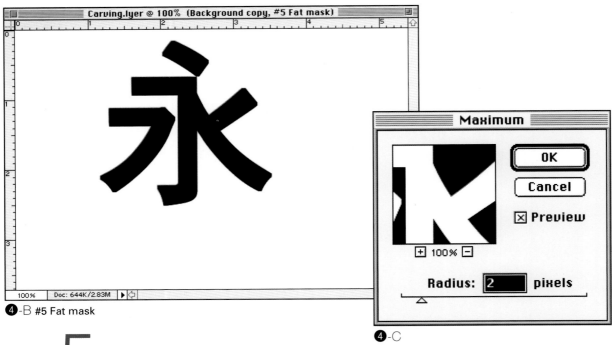

④-B #5 Fat mask

④-C

Step 5

Another duplicate was made from 'Original' and named 'Emboss/Highlight'. In this channel, I applied the Gaussian Blur filter and then stylized the image using the Emboss filter, "raising" the image from the background and creating a beveled edge. Before proceeding, another channel was made by duplicating 'Emboss/Highlight'. The newly created channel was named 'Shadow'. This was done so that the channel could be used at a later stage. Then the background of 'Emboss/Highlight' was converted to a 100% black high contrast image by selecting the black point eyedropper tool from the Levels dialog box and with it, clicking on the background of the channel. Next, Load Selection > Fat was chosen and the selected area was painted 100% black. This procedure was also repeated with the 'Original' channel, rendering the selected area 100% black as well. The 'Emboss/Highlight' channel was now ready to be used as mask for beveled highlighting in Step 7 (see fig. 5).

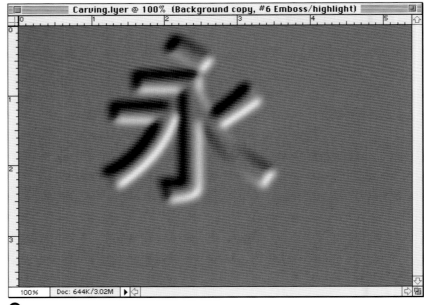

⑤ #6Emboss / Highligt

24

Step 6

Now I inverted the 'Shadow' channel and converted it to a high contrast image in 100% black using the same technique explained in Step 5. The 'Fat' and 'Original' channels were also chosen and painted 100% black as in Step 5 (see fig. 6-A). The 'Shadow' channel was now also ready to be used as a mask for beveled highlighting in Step 7. The 'Interior Shadow' channel was made by duplicating the 'Original' channel and applying the Gaussian Blur filter to the interior shadow of the character, offset by 45 degrees to the bottom right (see fig. 6-B).

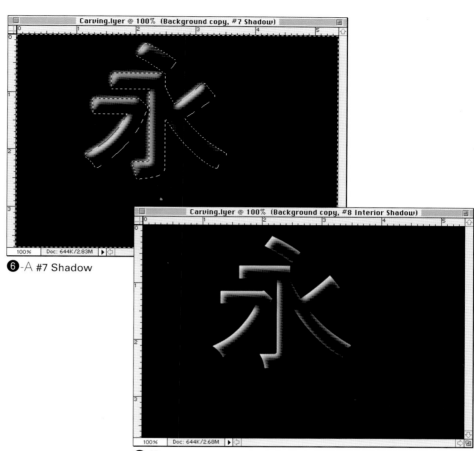

❻-A #7 Shadow

❻-B #8 Interior Shadow

Step 7

After reverting to RGB mode, the brightness of the masks for 'Original', 'Emboss/Highlight', 'Shadow' and 'Interior Shadow' was adjusted and fine-tuned with Levels while the unevenness of the beveled surfaces was adjusted until the desired effect was reached (see fig. 7).

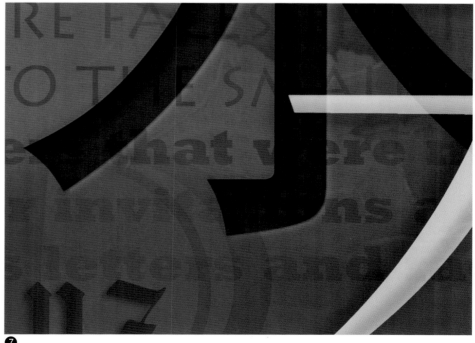

❼

Anders F. Rönnblom

Anders F. Rönnblom is an artist whose diverse interests range from digital art to rock music. Together with his wife, he founded the Stockholm-based design studio, Studio Matchbox. As a Macintosh-based artist, he has been active since 1985, producing a body of work that includes the publication *Mac Art & Design*. He has also worked on *The Digital Hall of Fame* exhibit, which has featured the works of many well-known digital artists in Europe. An accomplished musician, he has released over 20 CD titles under his own name.

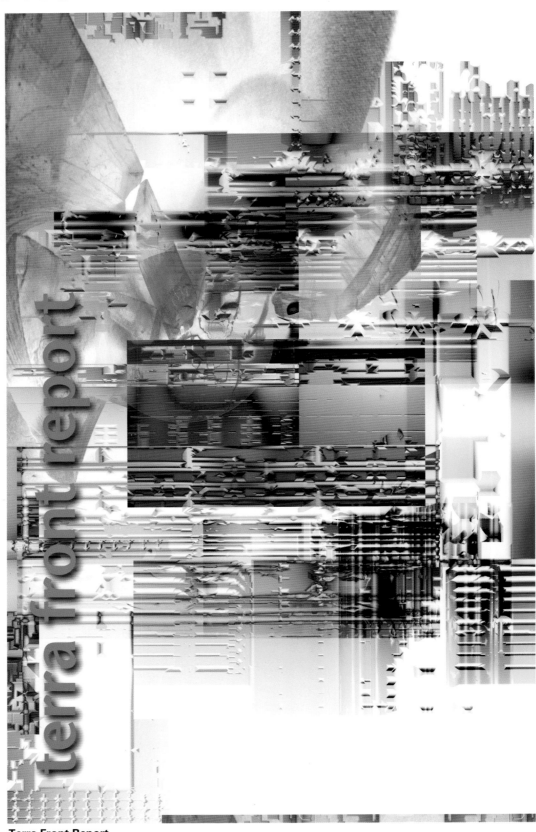

Terra Front Report
Terra Front: Brochure cover
Software: Pixar Typestry, KPT 3.0

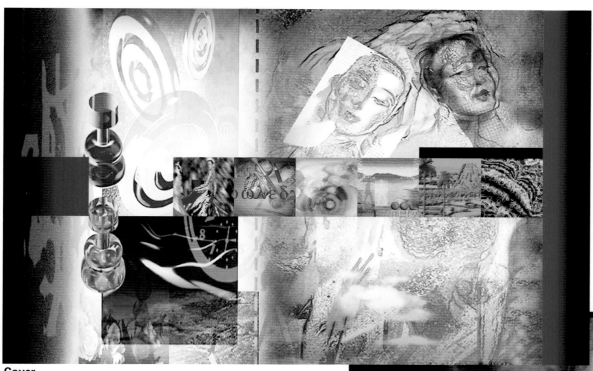

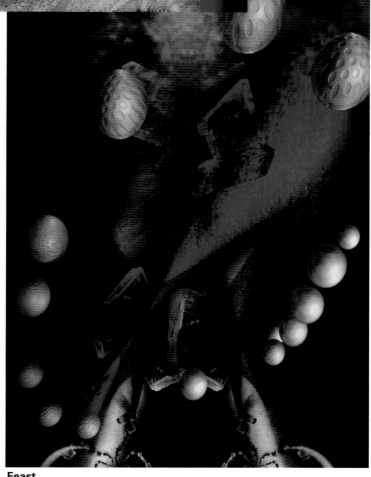

Cover
Hearst Publishing: cover for *Annual Digital Art Book*
Software: Live Picture, Pixar Showplace, Pixar Typestry, KPT 3.0, Painter

Master Dream
Studio Matchbox: Interactive CD-ROM
Software: KPT 3.0, KPT Convolver, Pixar Typestry

Feast
Ericsson: Illustration for computer magazine
Software: Pixar Showplace, PhotoDisc images

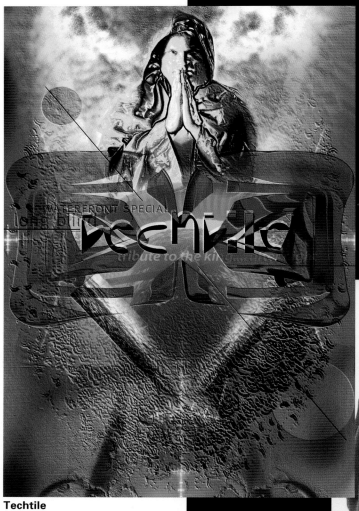

Techtile
Studio Matchbox: Interactive CD ROM
Software: KPT 3.0, KPT Convolver

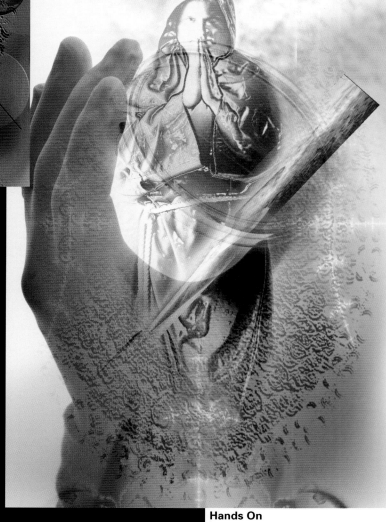

Hands On
Studio Matchbox: Interactive CD-ROM
Software: KPT 3.0, KPT Convolver

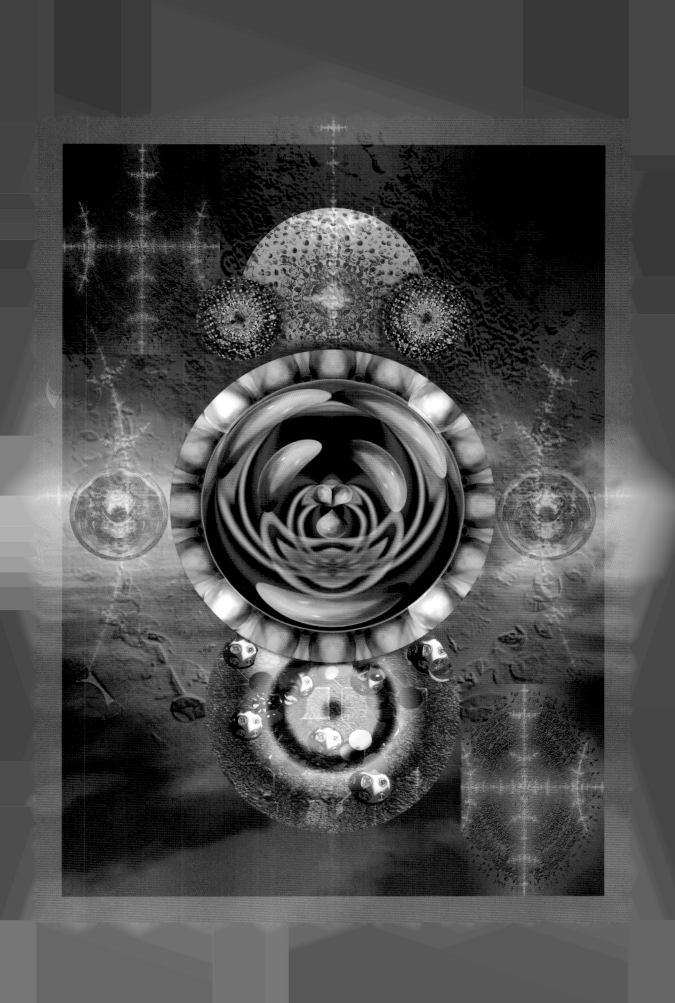

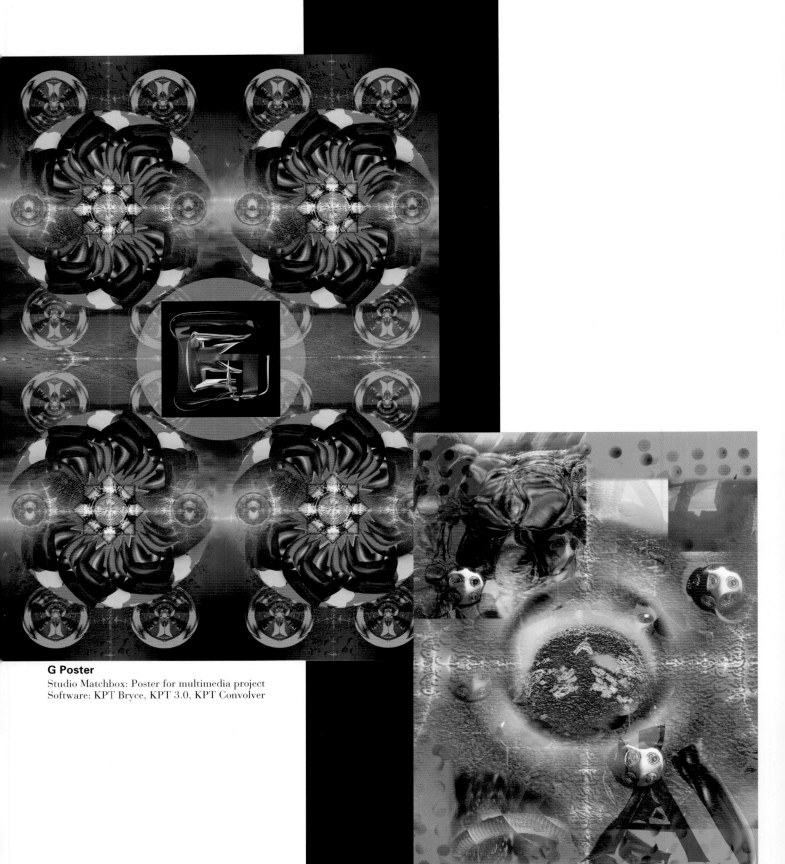

G Poster
Studio Matchbox: Poster for multimedia project
Software: KPT Bryce, KPT 3.0, KPT Convolver

Master Dream
Studio Matchbox: Illustration for multimedia project
Software: KPT 3.0, KPT Convolver, Pixar Tapestry

Lovely X-files
Robert Matton AB: Illustration for software brochure
Software: KPT 3.0, KPT Convolver, Live Picture

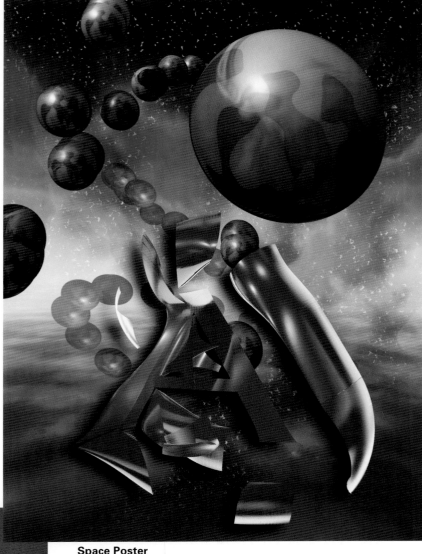

Space Poster
Studio Matchbox: Poster for 3D art seminar
Software: KPT Bryce, Pixar Showplace, Pixar Tapestry

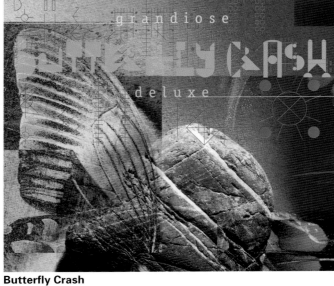

Butterfly Crash
Beechwood and Ryefields Society: Book cover
Software: KPT 3.0, KPT Convolver, Live Picture

Joanie Schwarz

Joanie Schwarz is a graphic artist based in New Jersey who specializes in illustration and custom portraits. Her works have been exhibited at The Society of Illustrators in New York and The New York Art Director's Club along with a host of galleries and private collections. She employs her experience in photography and painting to create works that are both sensual and evocative. She has been represented by Vicki Morgan Associates for the past eight years. She currently lives in New Jersey with her husband, two children and Suki, her "stunning, but not too intelligent dog."

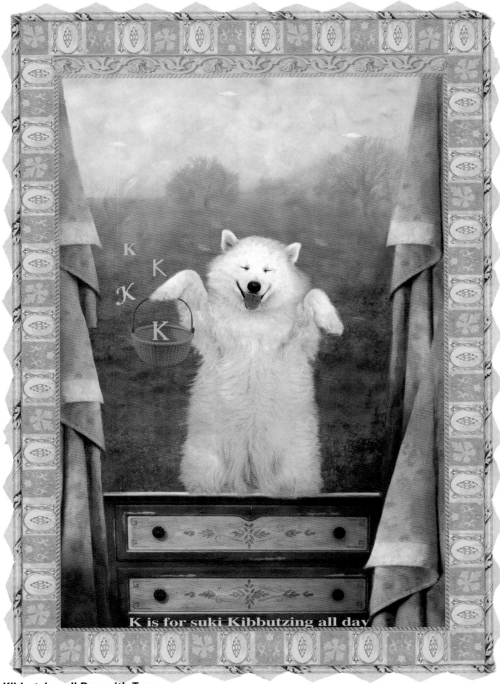

Kibbutzing all Day with Type
Random House: Children's book illustration
Software: Painter

An Angel Passed Over
Portrait
Software: Painter

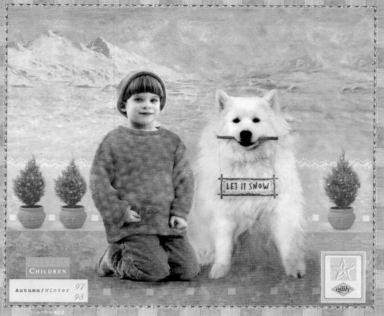

Let it Snow
Self promotion
Software: Painter

Do You Care at all for Me?
Random House: Children's book illustration
Software: Painter

US News & World Report
US News & World Report magazine: Article illustration
Software: Painter

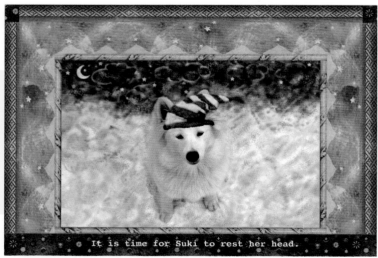

It is Time for Suki to Rest her Head
Random House: Children's book illustration
Software: Painter

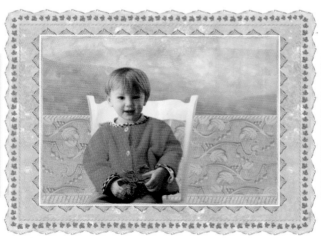

Lee at Two
Portrait assignment
Software: Painter

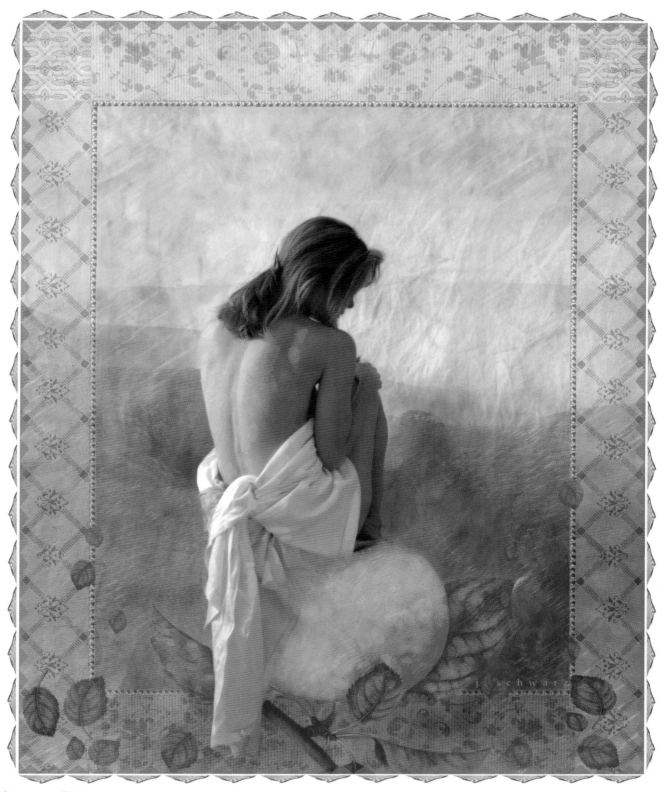

Showcase Girl
Self Promotion
Software: Painter

Tadanori Yokoo

Tadanori Yokoo is an artist as well known in Japan for his unique style as he is for his alleged extra-terrestrial encounters. Incorporating traditionally quintessential Japanese images such as Mt. Fuji, cherry blossoms and patterned sunrises into striking designs that explore both the erotic and psychedelic, he has created a body of work that has earned him international recognition and acclaim. Major exhibitions featuring his work have been held at the Museum of Modern Art in New York, the City Art Museum in Amsterdam and at the Biennale in Venice. In addition his art has been on display around the world in such places as Paris, San Paulo, and Bangladesh. Although his works represent a vast array of styles and influences, Yokoo began his career as a graphic artist, making posters for various theater troupes in Japan. Recently he has begun experimenting with digital art, incorporating video and 3D imagery into his artistic repertoire.

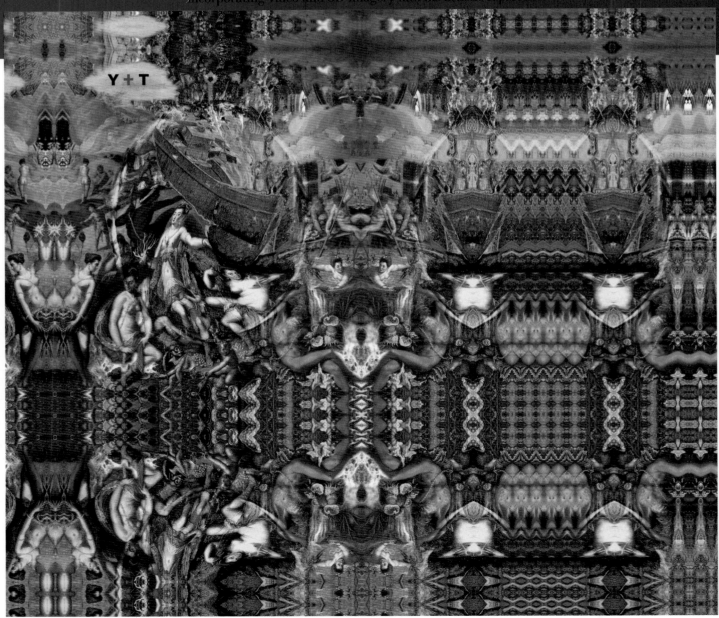

Festival for the Ocean God II
Original work

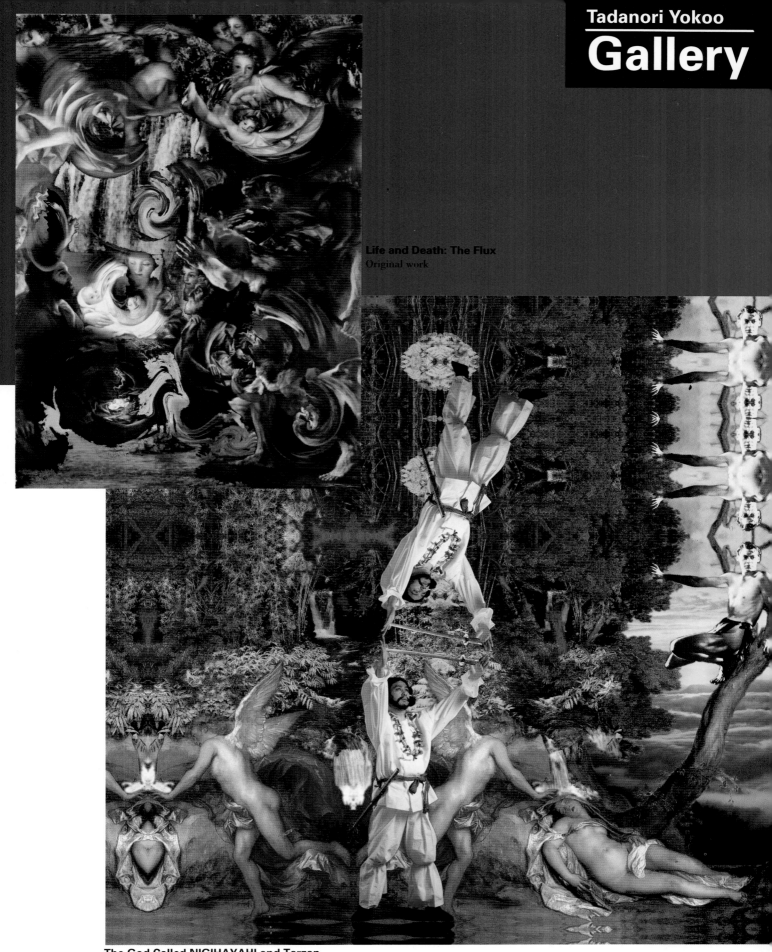

Life and Death: The Flux
Original work

The God Called NIGIHAYAHI and Tarzan
Original work

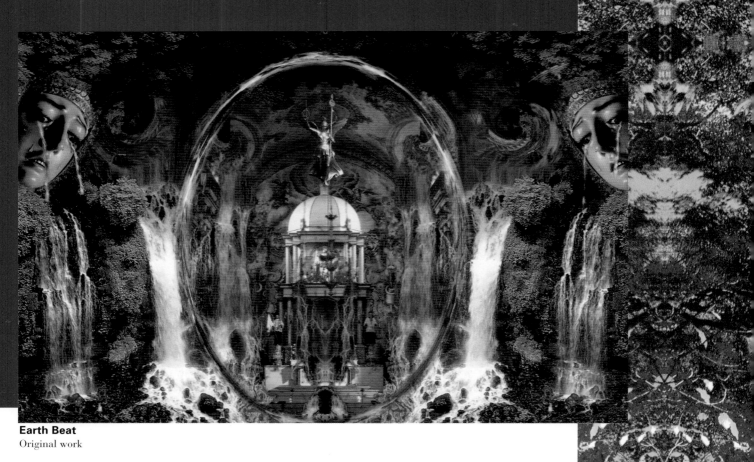

Earth Beat
Original work

Mirror
Original work

The Mantora Water Falls
Original work

38

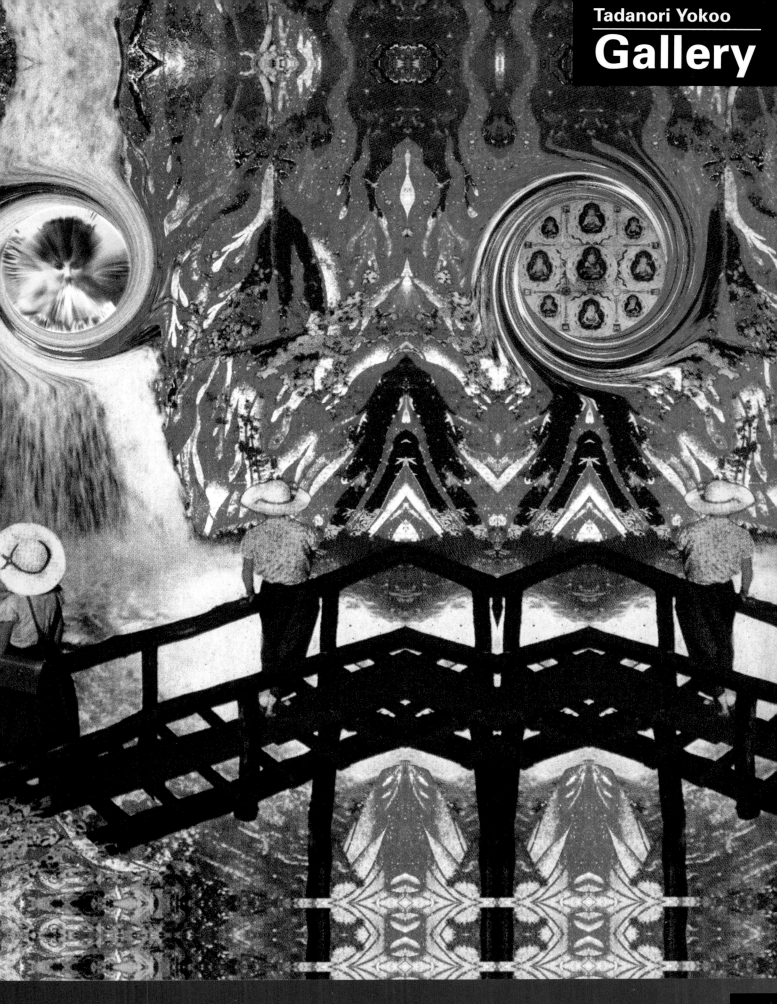

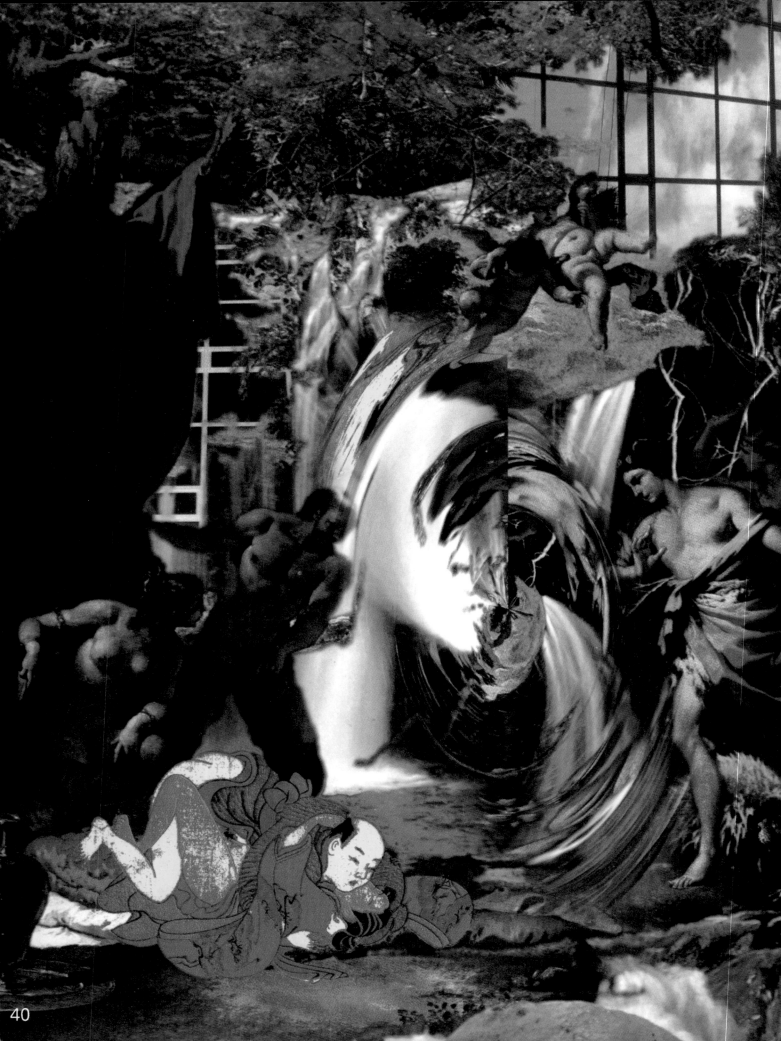

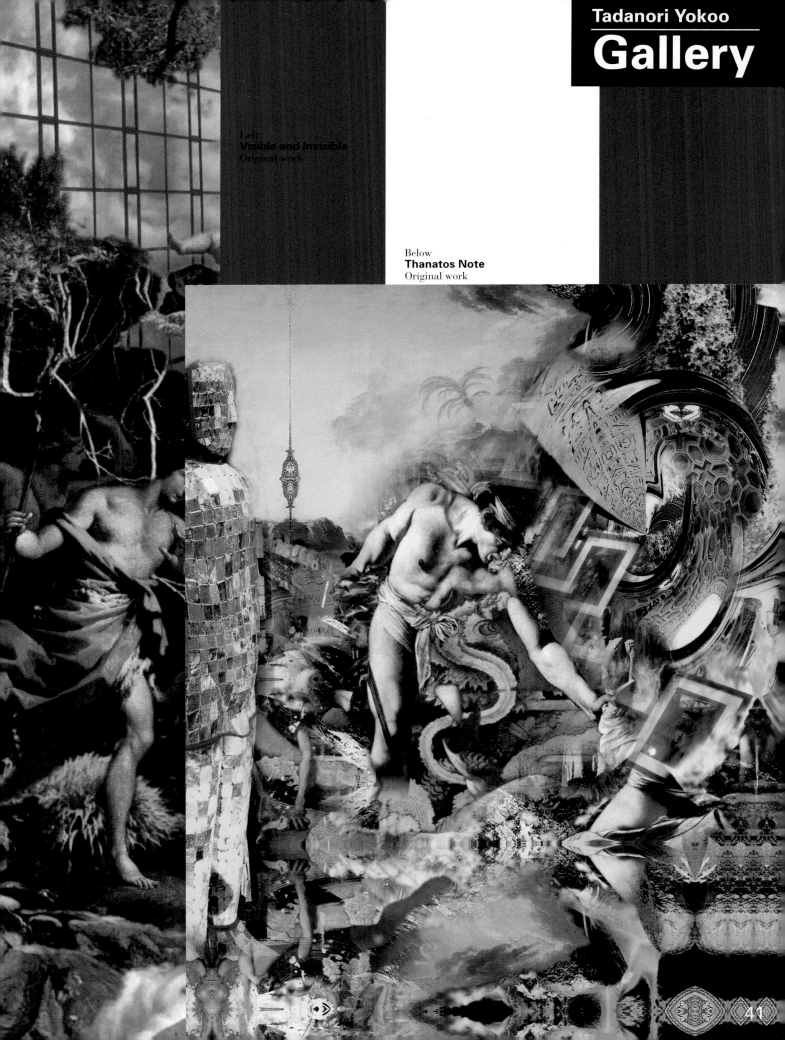

Left
Visible and Invisible
Original work

Below
Thanatos Note
Original work

Michael Schmalz

Michael Schmalz is a graphic artist based in Dubuque, Iowa who recently started his own design company with his brother Daniel called Refinery Design. After graduating from the Kansas City Art Institute in 1990, Michael Schmalz went to work for Hallmark Inc. A year later he decided that working for a large corporation was not for him, and accepted a position as art director at McCullough Creative Group in his hometown of Dubuque, Iowa. "Being located in such a small market with even smaller budgets, you have to learn to be the art director, the illustrator, the designer, and in some cases the photographer for your projects." His design and illustration work has been recognized by various magazines including *Communication Arts*, *Graphis*, *Step-By-Step Electronic Design* and *Print* magazine. He has also been recognized by Adobe and Macromedia for excellent and innovative use and application of their software products.

Driven Down Sign
Dupaco Community Credit Union: Illustration for advertisement
Software: Freehand

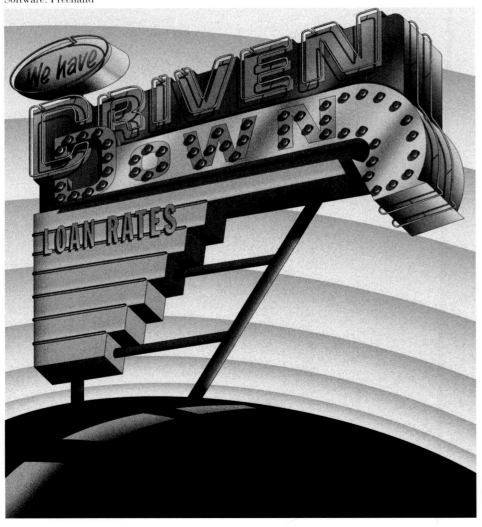

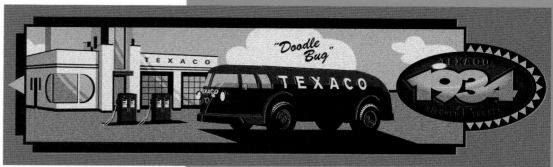

1934 Diamond T Tanker
Ertl International Toy Co. and Texaco: Package design illustration
Software: Freehand

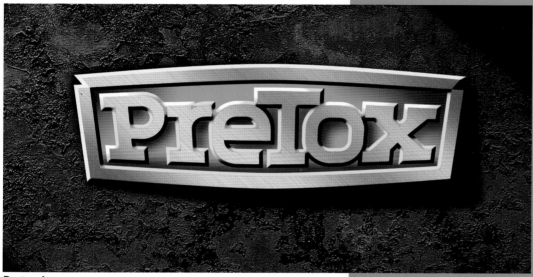

Pretox Logo
Westmark Inc.: Illustration for advertisement
Software: Freehand

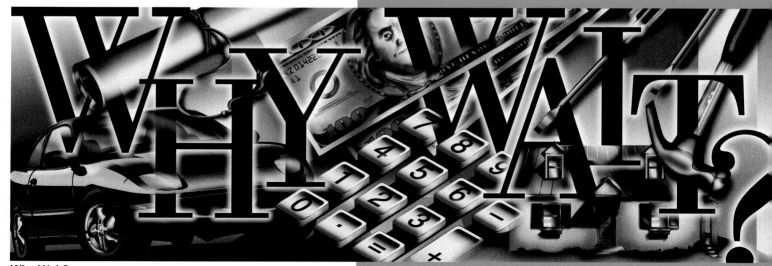

Why Wait?
Dupaco Community Credit Union: Illustration for advertisement
Software: Freehand

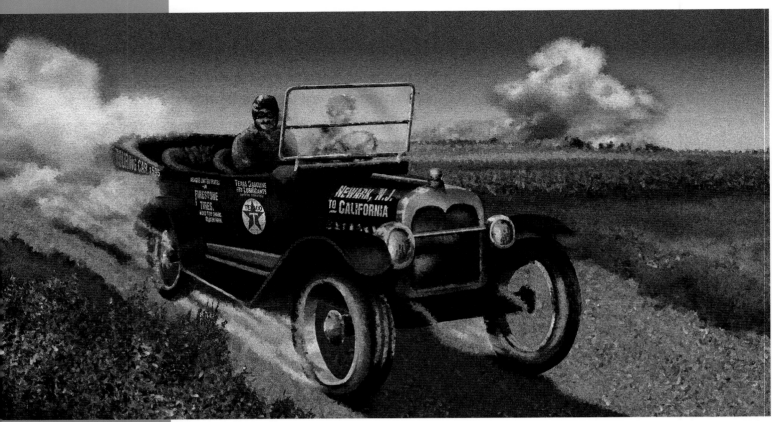

1917 Maxwell Touring Car
Ertl International Toy Co. and Texaco: Illustration for advertisement
Software: Freehand

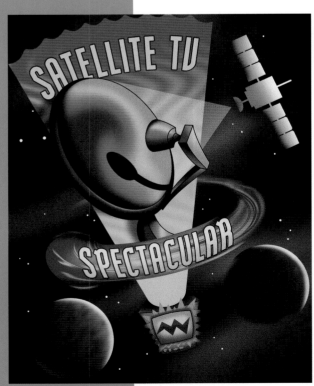

Satellite TV Spectacular
Radio Shack: Illustration for advertisement
Software: Freehand

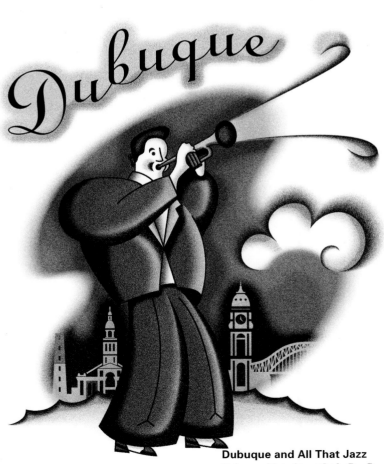

Dubuque and All That Jazz
Dubuque Main Street Ltd.: Pro Bono
Software: Freehand

Sturgis Rally & Races
Sturgis Limited Editions: Sales Promotion
Software: Freehand

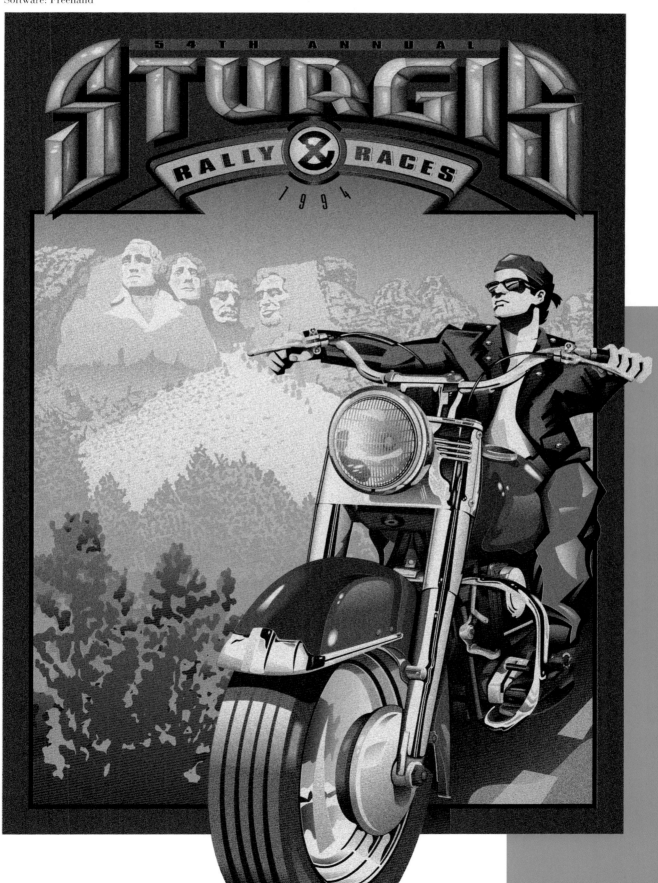

Shall We Dance ?

Assignment

Create a set of illustrations for an outdoor jazz festival. For this project, I used both *FreeHand* and *Photoshop*. While I usually work out my illustrations on paper first, the combination of both programs allows me to render the final composition with speed and precision. After the composition sketches have been completed, I scan them into *FreeHand* to create the black and white line work and the blending. These elements are then imported into *Photoshop* to be used as channels and masks when airbrushing and applying filters.

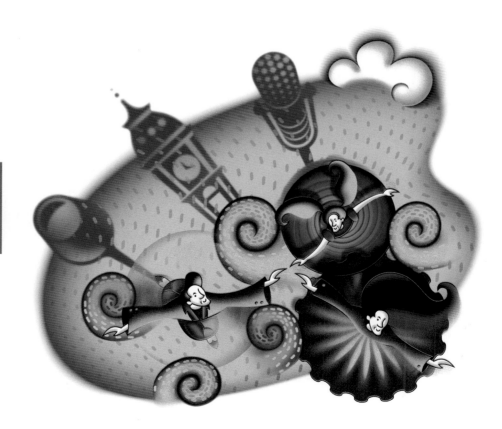

Step 1

Each element is drawn on a separate layer in *FreeHand*. For the dancers and the clock tower, I created outlines which I later modified in *Photoshop* (see fig. 1).

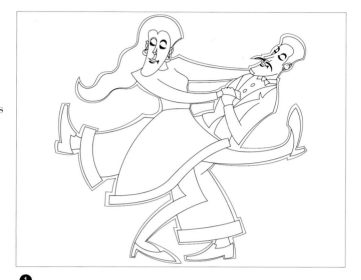

❶

Step 2

Once I had finished the main figures, I began working on the image's biggest challenge: the musical waves. To make a wave I drew a circle in *FreeHand*, selected it and Option-dragged to make copies. Scaling to 30%, I blended, ungrouped and dragged the circles until they touched (see fig. 2).

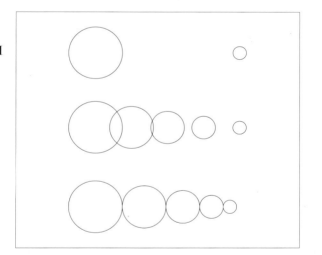

❷

Step 3

I scaled the circles down vertically by 50% to make ellipses, cut away half of each ellipse with the knife tool and joined the opposite end points. As the result was still rather rough, I selected the joined points and converted them to curve points by clicking the Curve Point icon in the Object Inspector palette. Then I adjusted each curve for a more fluid path (see fig. 3).

❸

Step 4

I then created a four-step blend in a smooth arc across the page. I worked out the wave's basic fan shape by drawing a line, rotating a copy and blending between them. When I was satisfied with them, I used the same settings on the wave copies. I fine-tuned the placement of each wave so that relationship of waves with the dancers and clock tower was visually pleasing. Before creating the final blends, I opened *FreeHand's* Document Inspector palette and set the resolution to 2540 dpi so the proper number of steps would be used for each blend (see fig. 4).

❹

❺

Step 5

The waves were grouped into five large light-to-dark clusters. Painting the clusters was made easier by generating light-to-dark blends in *FreeHand* and blending between the waves. To shade the waves, I cloned the middle four waves so that each area was defined by a pair of waves. I then stroked the top wave of each pair with white and stroked the bottom wave with black. The pairs were cloned into a new layer while the area between each pair was blended (see fig. 5).

Step 6

Smaller blends were made to allow me to paint each wave individually. Blends for each wave were also needed. In the layer created in the prior step, I applied a ten-step blend between each pair of waves in order to create outlines for the new blends. Again, I cloned the middle waves so that each area was defined by a pair of waves, and gave the bottom waves a black stroke while the top waves received a 20% gray stroke. The areas were then blended as well (see fig. 6).

❻

Step 7

Another blend was created for a fade effect on the top and left hand side of the image. Blending between two corners created a shape which I used to fade out the image on the left hand side. I saved each layer in a separate file and then exported the files in *Illustrator* format so the files could be used in *Photoshop* (see fig. 7).

❼

Step 8

In *Photoshop*, the dancers, clock tower and waves were saved in three different files to keep file sizes manageable. A composite file was also made with each of the elements placed in its own channel. To paint the dancers, I opened the composite, copied the channel with the sketch of the dancers, and pasted it into a channel in a new file to use as a painting guide. Since the sketch had a closed outline around each color area, I could activate the channel and select areas with the magic wand tool. Using Select > Expand, I enlarged the selection by one pixel and used the airbrush tool to paint the selection (see fig. 8).

C	100	C	100	C	100	C	100
M	70	M	95	M	45	M	0
Y	0	Y	0	Y	0	Y	100
K	100	K	0	K	0	K	36
C	85	C	40	C	0	C	0
M	0	M	0	M	100	M	50
Y	100	Y	90	Y	100	Y	100
K	0	K	0	K	0	K	0
C	0	C	0	C	30	C	0
M	15	M	100	M	100	M	100
Y	100	Y	0	Y	0	Y	100
K	0	K	0	K	18	K	100

❽

Step 9

To create a glow around the dancers, I added a new layer which I placed beneath one of the dancers. I loaded the outline channel which I had made earlier into the new layer, filled it with yellow and then airbrushed in with red. When I was satisfied with the way the outline looked visually, the two layers were merged. Following the outline in the channel, I used the airbrush with a very small brush size to paint in the tiny black outlines that defined the figures.

Step 10

I loaded the narrow waves into a channel in *Photoshop* and painted them with shades of blue and violet. I varied the colors but generally worked from light to dark. Because the original wave images graduated from gray to black, working in the channel created a dimensional effect by masking out more paint at the top of each wave and less at the bottom. The broad waves were also loaded into a channel and painted with a cool black to add large-scale shading. I used the Graphic Pen filter to add texture to the edge of the wave area (see fig. 10).

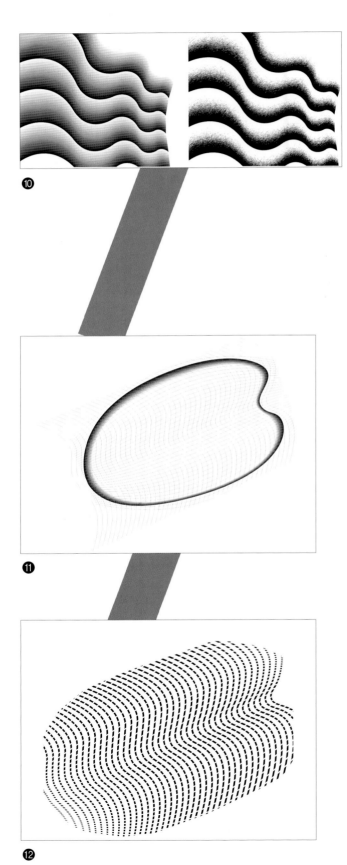

❿

Step 11

To create the ground and the blades of grass on the aerial view illustration, I first used the pen tool in FreeHand to draw the shape of the ground. I then cloned the shape and used the scale tool to reduce it slightly. I adjusted and blended the two shapes to create the ground's soft edge. Blending the two shapes gave me the soft edge for the ground and a guide for drawing the blended lines that would create the blades of grass (see fig. 11).

⓫

Step 12

I imported the blades of grass into a different layer. Using the pen tool, the top, bottom, right and left outer lines were drawn. I blended the left line into the right line with a forty step blend and blended the top line into the bottom line with a thirty-three step blend. With the horizontal lines on top, I changed their stroke to white with a value of 6 points and the vertical lines to black with a value of 6 points. After sending the horizontal lines to the front and changing the stroke to white, I imported the resulting dashed lines into *Photoshop* (see fig. 12).

⓬

Step 13

In *Photoshop*, I used the eraser tool to erase half of the blades of grass in an alternating pattern. Then I used the Dust & Scratches filter with a nine pixel radius and a threshhold level of zero to round the edges of the grass blades (see fig. 13).

⑬

Step 14

For the dancer's skirt, I drew two ellipses with a smaller white ellipse inside a larger black one to create a pleat. I ungrouped the two and step blended them together. The pleat was cloned and rotated 20° around a center axis and duplicated to create a total of 18 pleats around the axis. I imported the image into *Photoshop* to use as a channel to airbrush the dress (see fig. 14).

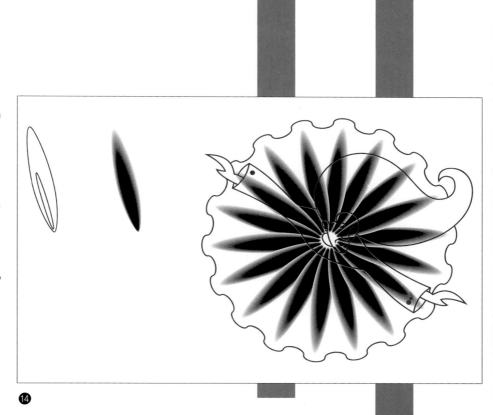

⑭

Step 15

For the final step I added texture to both illustrations by applying the Add Noise filter to each file, with the amount set at 40 and the Gaussian button checked. Since the filter adds noise across the entire illustration, I loaded the outline files and painted the white of the paper back in.

dav Mrozek Rauch

dav Mrozek Rauch is an animator and motion graphics designer currently employed at eMotion Studios. He enjoys working on experimental video, internet and theatrical projects that incorporate technology and art. His first major video project, "queer", was honored and has been shown at film festivals in San Francisco, Washington D.C. and New York. He has worked on several experimental projects including a multi-channel video totem pole, a Butoh dance performance supported by the Rockefeller Foundation and French Ministry of Culture, an animation festival in the Czech Republic, and an auto-editing documentary. "A Taurus on the Cusp of Aries," Rauch enjoys sunset jaunts along the beach, cooking and eating.

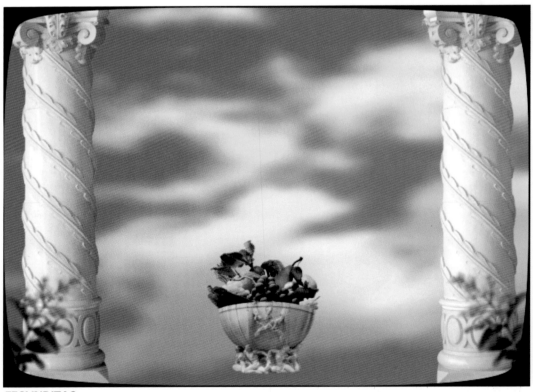

FECVNDITAS
Personal project
Software: Illustrator, After Effects

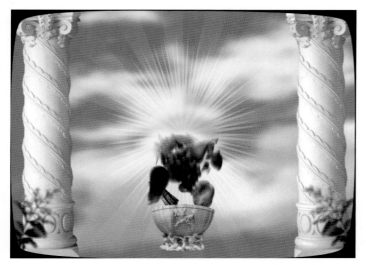

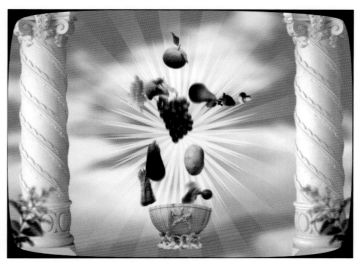

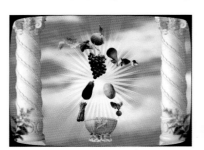

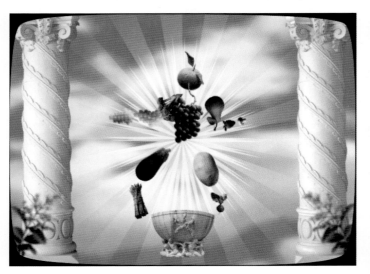

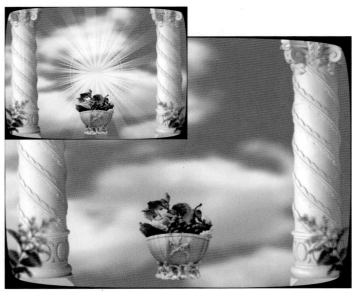

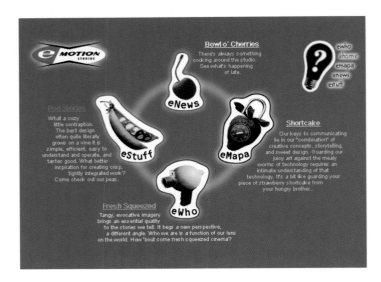

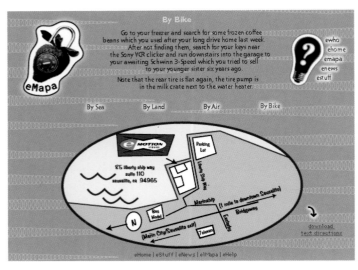

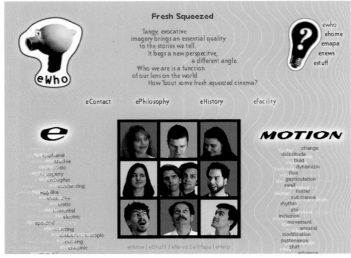

eMotion Web Site

eMotion studios: Web site

Software: Illustrator

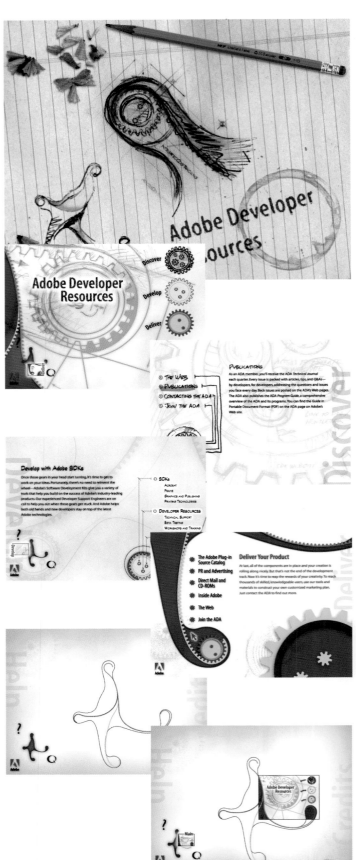

Adobe Developer Resources

Adobe Systems Inc.: CD-ROM project

Software: Illustrator, After Effects

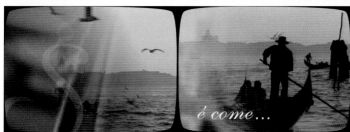

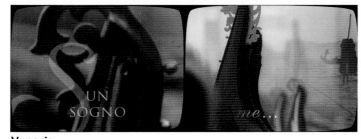

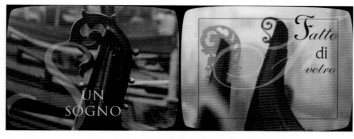

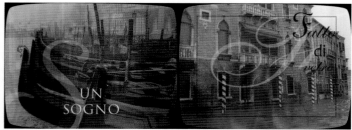

Venezia

Adobe Systems Inc.: Promotional Video

Software: Illustrator, Premiere

FECVNDITAS

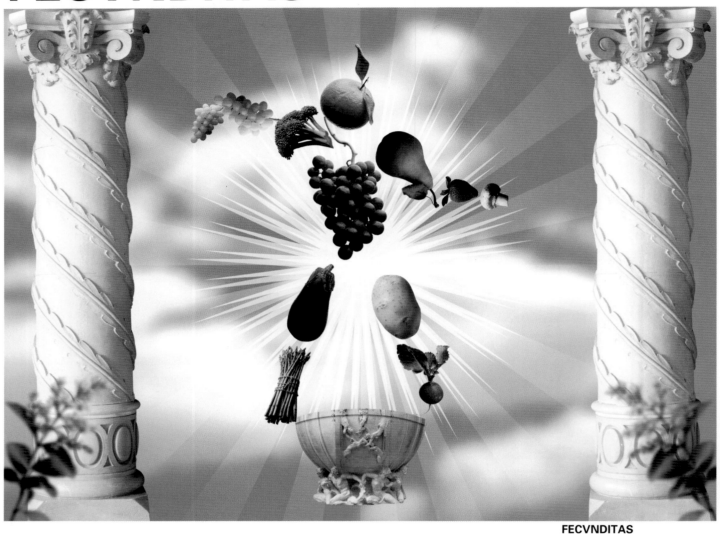

FECVNDITAS
Personal project
Software: Illustrator, After Effects

Step 1

First I adjusted the dimensions of the cloud image by increasing the image size 10% vertically and a 100% horizontally. By using the Levels slider I gradually lightened the image until I created the visual effect I wanted. Then I blurred the image heavily using the blur tool (see fig. 1-A and 1-B).

❶-A

❶-B

Step 2

Next I exported a frame from a video clip of an artist named Yasmina Porter and dragged it into the cloud image (see fig. 2-A). I was able to isolate Yasmina from the background using a Layer mask. Using her pose as a template, I began placing various fruits in different positions in the image corresponding to the different parts of her body (see fig. 2-B). First I made a copy of the fruit that I wanted to transform. By using the Free Transform command I was able to rotate and resize the various copied fruits to get a rough approximation of how the fruits would be placed over the dancer.

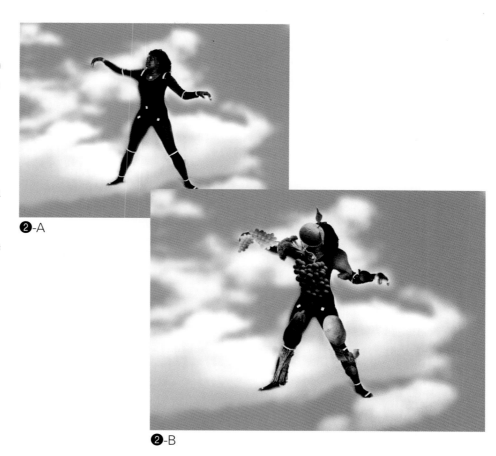

❷-A

❷-B

Step 3

After I was satisfied with the size and placement of the fruits, I dragged the composition into the original fruit layer and again used the Free Transform command to rotate the original fruit to match the positions of the copied fruit. When resizing I first determined the size of the copied fruit by checking the pixel dimensions of each copy. Then I tightly cropped the original fruit and used the Image Size command to alter the dimensions to the appropriate size (see fig. 3).

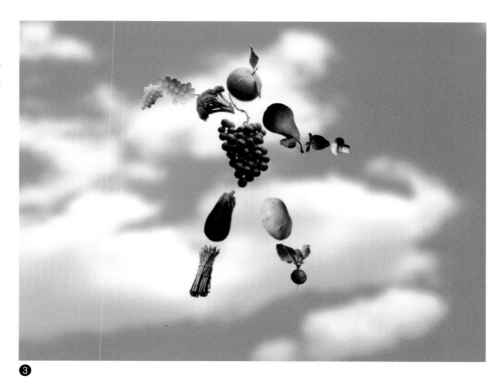

❸

Step 4

To create life-like motion in the different parts of the "body", I decided to use the Radial Blur command with a slight modification. Although the Radial Blur command simulates the blurring of objects rotating at greater or lesser degrees, it assumes the center of the blur to be the center of the entire document, so it will blur objects differently based on where they are placed in the frame (see fig. 4-A).

NOTE: Not all grapes blur equally. The same Radial Blur has been applied to three different grape layers, each in a different position to illustrate this point.

To use this discrepancy to my advantage, I began by dragging a copy of all the fruit from the clouds image into another file. I then positioned the fruit into the frame according to the rotation and the degree of blur I wanted for each fruit. Fruits that I wanted to be heavily blurred were placed farthest from the center while fruits that needed only a slight blur were positioned near the center of the document. Then I applied the same Radial Blur command to each layer of fruit in the document (see fig. 4-B). Finally I placed the blurred fruit back into the original file and positioned them on top of the non-blurred fruit.

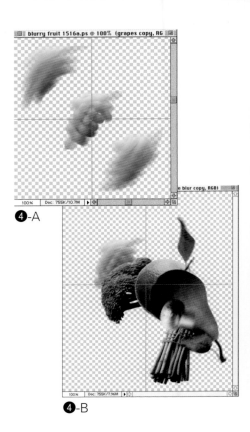

4-A

4-B

Step 5

To draw attention to the center of the composition where the dancing fruit had been placed, I decided to add some "angelic" light to the image. I created some sun rays in *Illustrator* and imported them into *Photoshop* (see fig. 5-A and 5-B) When importing into *Photoshop*, I selected Paste as Pixels to rasterize the document.

NOTE: The crop marks are set to the size of the *Photoshop* frame currently in use and that the blue background is only used to distinguish the rays.

5-A

5-B

Step 6

To create the appearance of the sun rays fading out from the center of the image, I used the marquee tool to create an elliptical selection around the fruit and the bowl and then blurred the edges of the selection by choosing a feather selection with the feather radius set to 80 pixels. To apply this selection to the sun rays, I simply clicked the Add Layer Mask button at the bottom of the Layers palette. Then I lowered the opacity of entire layer (see fig. 6-A and 6-B).

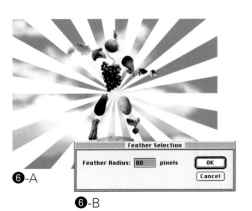

6-A

6-B

Step 7

Next I took an *Illustrator* file that I created called the "sea urchin" and imported it into the composition. To create more motion in the sea urchin image, it was rotated, the size was decreased and the opacity lowered. I added two columns to the composition and lightened them slightly with the Levels slider. In addition, some lilac was added and then blurred to add depth to the entire composition (see fig. 7-A and 7-B).

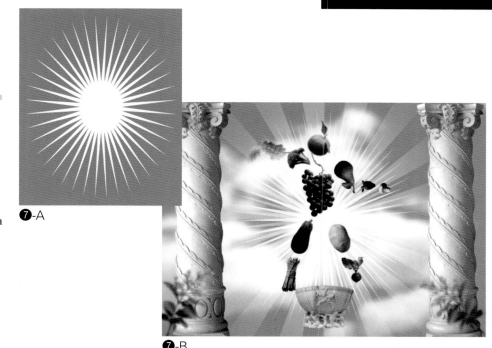

❼-A

❼-B

Step 8

Since all the objects used in the piece were photographed at different times with different lighting, color correction was needed to compensate for the inconsistencies in tone and brightness. For this composition I decided to use the Lighting Effects filter to create the effect I wanted (see fig. 8).

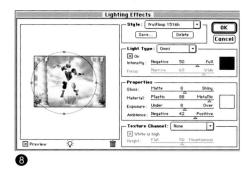

❽

Step 9

The effect produced by the Lighting Effects filter alone proved to be too extreme so in order to tone down the effect, I decided on a composite image consisting of several layers (see fig. 9-A). The original image was placed in the background and above it I placed the image which had been modified by the Lighting Effects filter, but in Color Transfer mode with the opacity reduced to 70%. Since the fruits were already brightly colored before the Lighting Effects filter was applied, they became oversaturated with the filter. To correct this, another layer of "dancing fruit" was placed on top, this time using Normal Transfer mode with the transparency reduced to 50% (see fig. 9-B).

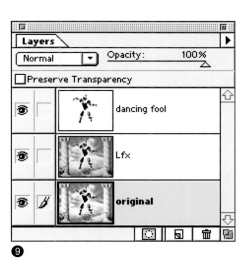

❾

Yukinori Tokoro

Yukinori Tokoro is an accomplished photographer and digital artist based in Tokyo. His interest in photography started at a young age, after receiving a camera from his parents. As a teenager, he was swept away by the pachinko (a type of pinball) craze that hit Japan and used his winnings to purchase photographic equipment. His recent success as an artist has been attributed to his experimentation with computer-generated graphic design. Using programs such as *Photoshop*, his mixed-media compositions have won praise in the field of digital art as well as photography. In 1994, he received the Grand Prix Award at the Windows Multimedia PC Grand Prix. A featured artist in the government sponsored An Exhibition of the History of Japanese Photography, he has been noted for seeking out original methods of expression through experimentation.

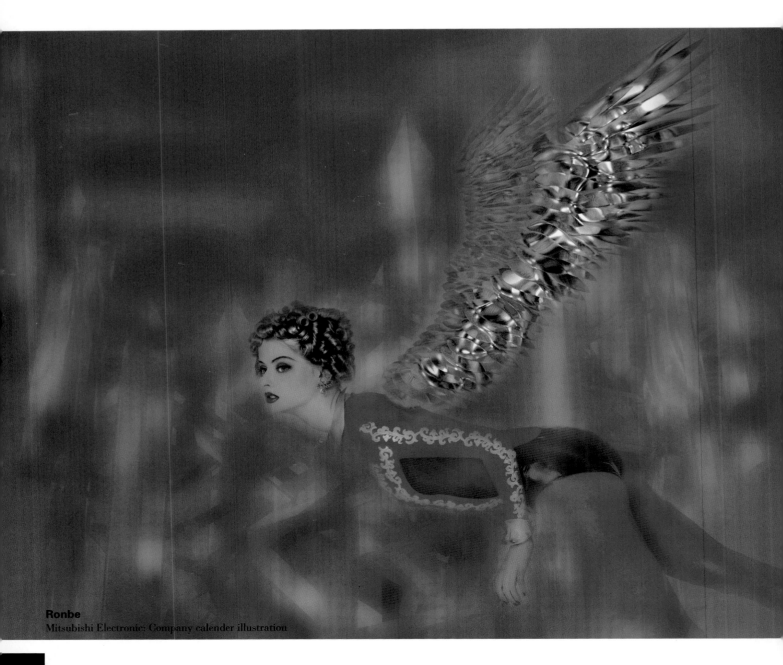

Ronbe
Mitsubishi Electronic: Company calender illustration

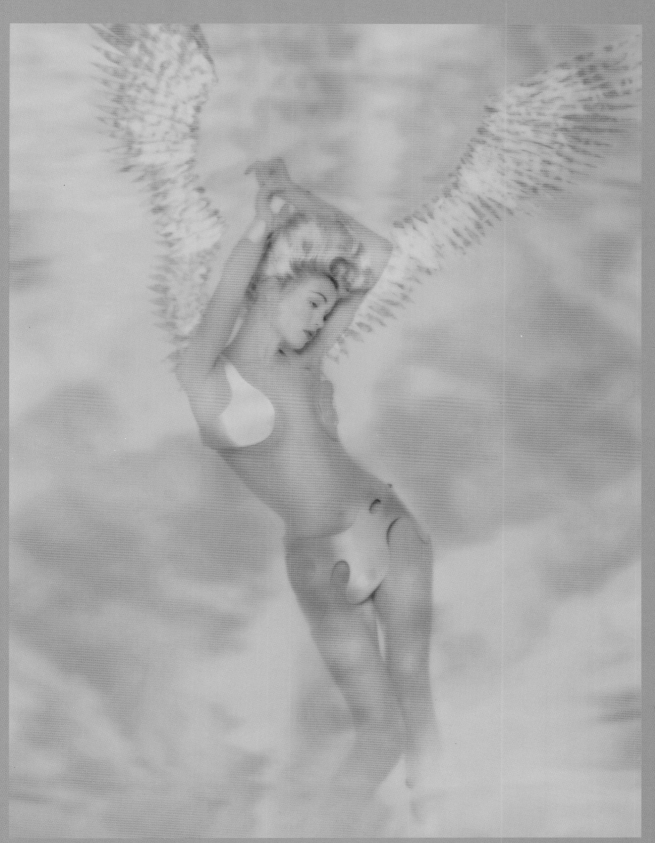

A Small Sun Reflected in the Water
Mitsubishi Electronic: Company calender illustration

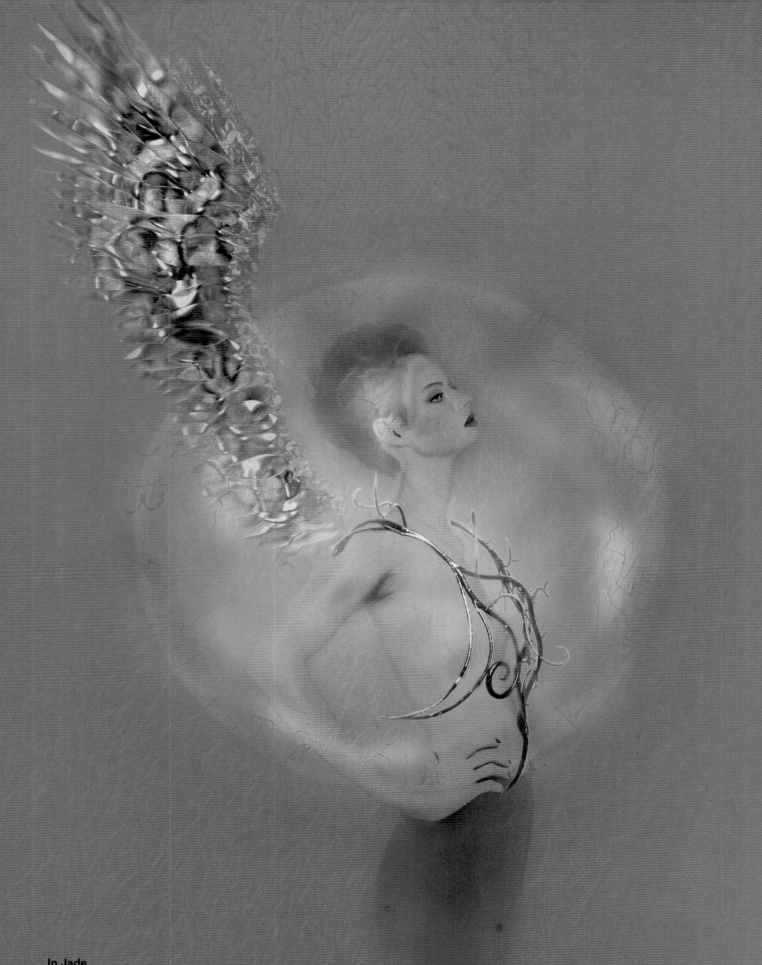

In Jade
Original work

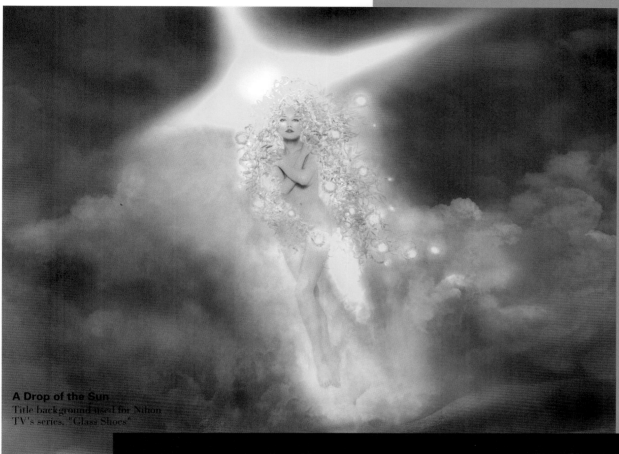

A Drop of the Sun
Title background used for Nihon TV's series, "Class Shoes"

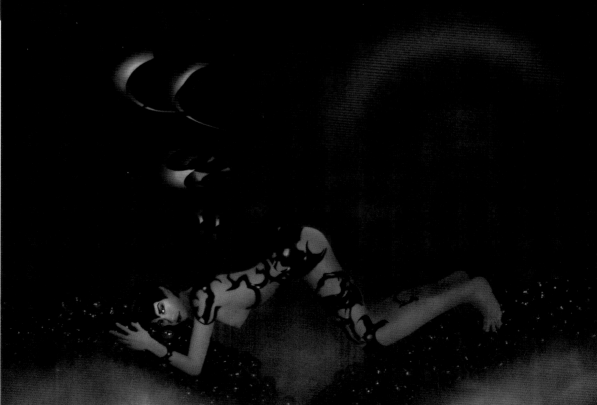

Ivy in the Darkness
Original work

Katrin Eismann

Katrin Eismann is a respected lecturer and teacher on the subject of imaging and the impact of emerging technologies upon the professional photographer and the fine artist. Her company, PRAXIS.Digital Solutions has taught and lectured throughout Europe, North America and the Asian-Pacific region for companies including Eastman Kodak, Adobe Systems and World Press Photo. Eismann's creative work is based upon investigating concepts and working with the appropriate technologies to create effective images. Her works have appeared in *The Photoshop Wow! Book*, *Adobe Photoshop Studio Secrets*, *IdN* magazine and at MacWorld.

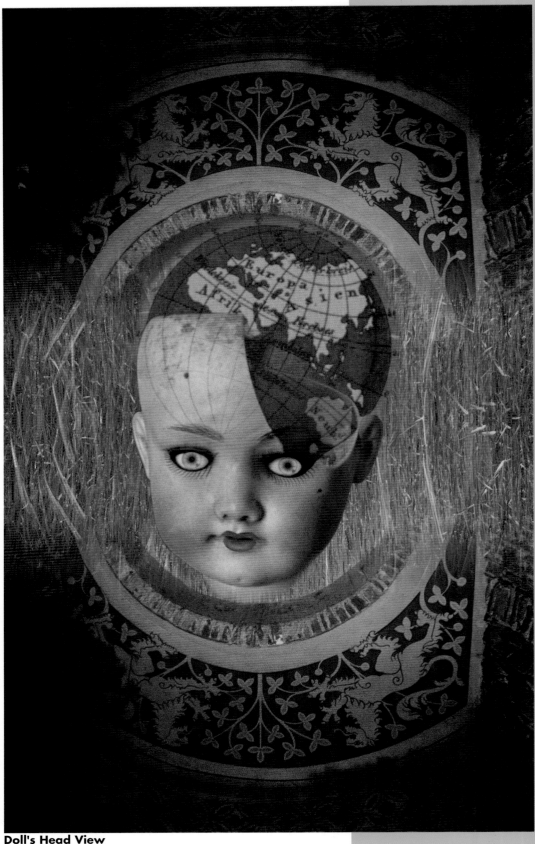

Doll's Head View
Macworld Conference: Image used for lecture

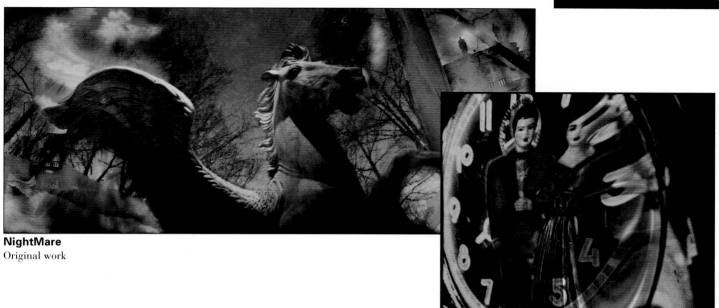

NightMare
Original work

Bride & Groom
Kodak AG: Digital camera portfolio

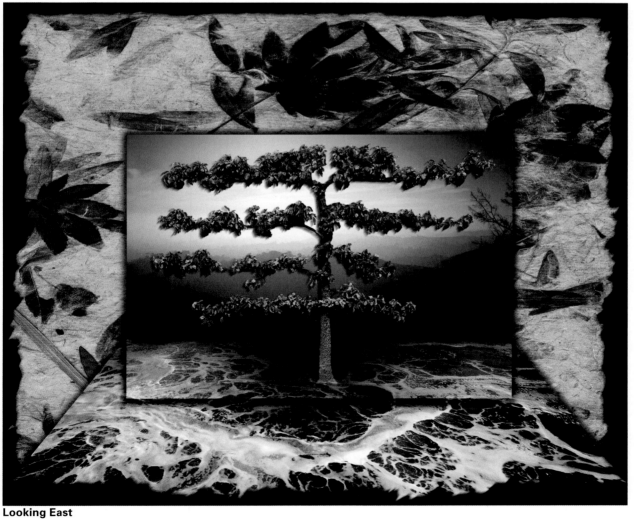

Looking East
Macworld magazine: Editorial illustration

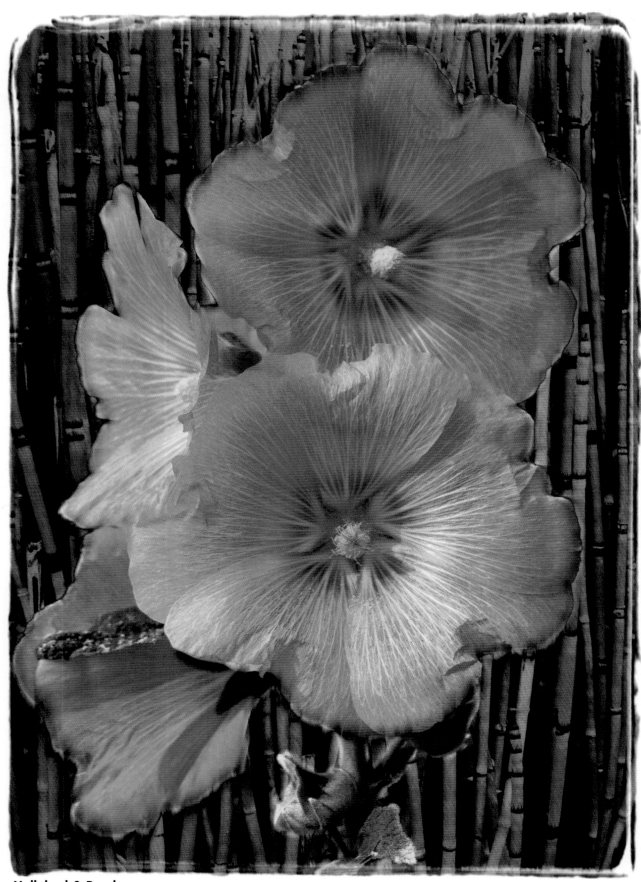

Hollyhock& Bamboo
Original work

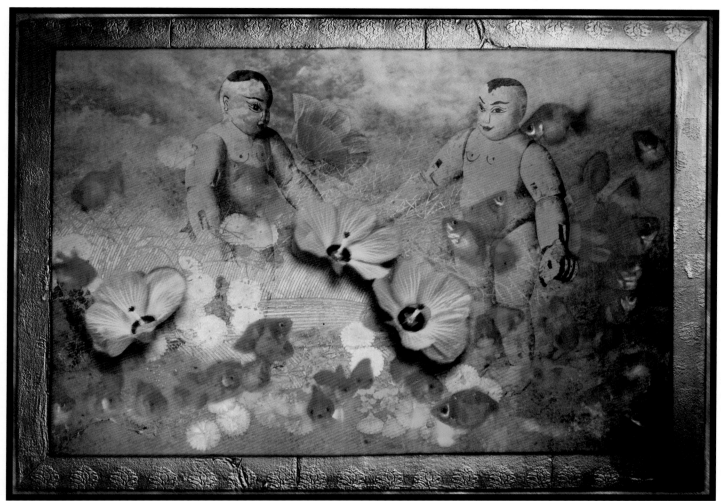

Paradise Lost
Original work

History's Passing Games
Original work

Water Babies
Techniques Conference: Image used for lecture

Creative Edges, Don't be Square

Of all the image making processes, digital imaging is the most precise. The computer gives us the ability to change a single pixel or to make radical changes to the entire image. Yet it is this power and precision that gives an 'artificial' feel to many images created using a computer. The perfection of the image making process can eliminate any sense of human craft, those interesting imperfections and idiosyncrasies that come only with work done by hand. Using creative edges can be an effective tool to give computer generated images a hand-made appearance. In the following pages, I will explain four techniques that can add a unique character to any image.

Technique ①

Creative Edges with Quick Mask & Built-in Filters

Working with Quick Mask to break up edges is a quick and easy method to add texture to the edge of any image.

Step 1

Open your image in *Photoshop* and with the marquee tool select the inside of the image that you wish to remain unaffected, leaving a border of unselected pixels around the image where you would like the edge to be affected. Press Q on the keyboard to activate the Quick Mask mode. Then press Command + I (Macintosh) or Control + I (Windows) to invert the mask and use a Gaussian Blur of 6 on the mask to soften the edge (see fig. 1-A and 1-B).

①-A

①-B

Step 2

Experiment with *Photoshop*'s filters to change the edges of the Quick Mask (see fig. 2-A and 2-B).

Good filters to try include:

Filter > Brush Stokes > Spatter
Filter > Brush Stokes > Sprayed Edges
Filter > Distort > Glass
Filter > Sketch > Torn Edges
Filter > Texture > Craquelure

Of course, you can use more than one filter on the Quick Mask if desired.

❷-A

❷-B

Step 3

When the desired effect is reached press the Q key again to make the Quick Mask an active selection. Fill the selection with your chosen color. Press the D key to return foreground and background colors to the default black and white. Use the Delete key to fill the active area with white (see fig. 3-A and 3-B).

❸-A

❸-B

Examples of creative edges with the Spatter Filter

high resolution

low resolution

Textured Frames from Photographs

The textures and tones from a photograph are excellent resources from which to create creative edges. Carry a small point and shoot camera to capture images with interesting textures including tree trunks, rough walls, stony beaches and gravel paths along with other abstract patterns.

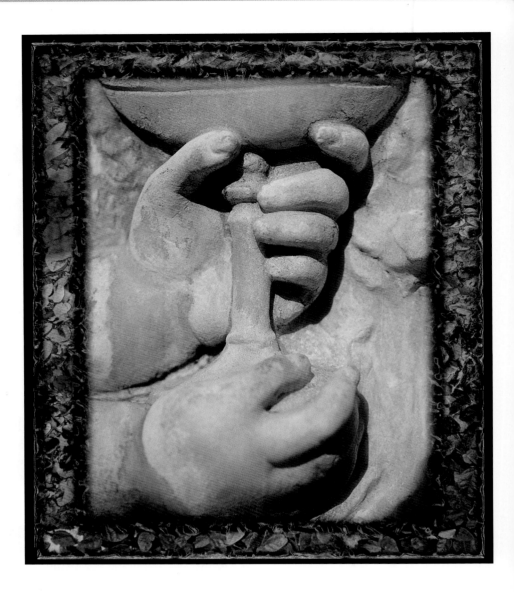

*Step*1

Open up the image that will serve as the texture. Convert it to grayscale and increase the contrast using Curves from the Image > Adjust submenu (see fig. 1).

❶

Step 2

Drag and drop your texture image on top of the image to be framed and decrease the opacity so that you can see through to the bottom layer. With a feathered marquee tool select the inside of the texture layer, inverse the selection and add a layer mask to the layer with the texture (see fig. 2-A and 2-B).

②-A

②-B

Step 3

Click on the layer icon to activate the layer and begin to experiment with blend modes and filter combinations to achieve an abstract effect. In this case, I used the Difference blend mode and the Emboss filter to create the desired effect. Duplicating the frame layer allows for further creative combinations (see fig. 3-A and 3-B).

③-A

③-B

Step 4

Command + click (Macintosh) or Control + click (Windows) on the frame layer to load its transparency. Border this selection by 10 and use Command + J (Macintosh) or Control + J (Windows) to duplicate the selection onto its own layer. Use the Chrome filter to add the final silvery effect (see fig. 4-A through 4-C).

④-A

④-B

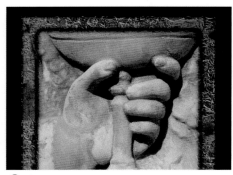

④-C

Adding Texture from Scanned In Objects

Scanning objects with a flatbed scanner to capture textures or shapes and then creating creative edges or frames is an effective method to add visual interest to images.

Step 1

The driftwood was scanned in with a UMAX PowerLook II Scanner. By selecting and dragging the pieces into an empty Photoshop file, I created the frame. Using Free Transform allows me to easily shape and position the pieces (see fig. 1-A thru 1-C).

❶-A

❶-B

❶-C

Step 2

Drag the frame image on top of the image to be framed. Duplicate the frame to experiment with blend modes. In this example, fig. 2-A is set to Luminosity Blend mode and fig. 2-B is set to Multiply Blend.

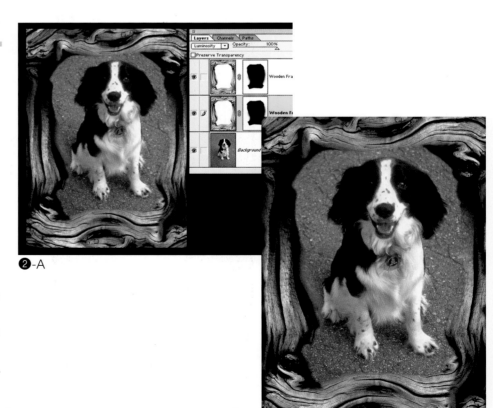

❷-A

❷-B

Step 3

Finally, I used the Quick Mask technique as described above with the Wave filter to soften the edges of the frame and create a more organic edge.

Using Third Party Plug-ins to Add Texture

Using the third party plug-in by Auto F/X allows you to easily add photographic, painterly or abstract edges to any image. The Auto F/X filter is a combination of a plug-in that is installed in the *Photoshop* plug-ins folder and the files on the Auto F/X CD.

Step 1

Here, I wanted to focus the viewer's attention on the horse. I used Filter > Auto F/X to open the filter interface (see fig. 1-A and 1-B).

❶-A

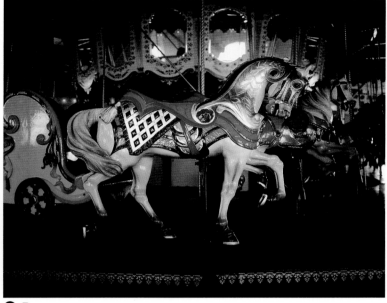

❶-B

Step 2

By browsing the CD's catalogue you can choose your desired edge effect. The effects of altering the inset, outset and blur controls can be seen in the image preview to the right of the control sliders in the interface (see fig. 2-A thru 2-C).

❷-A

❷-B

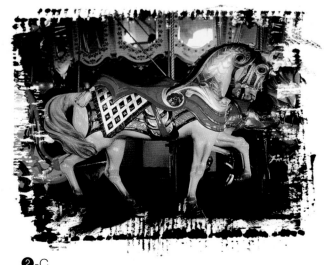

❷-C

In conclusion, each of these techniques allows you to effectively frame and finish images. Remember, the edges of an image can serve to capture a viewer's interest. Do not overlook the edges of your images as a place to experiment and expand your creative palette.

Glenn Mitsui

Glenn Mitsui began his career as a graphic artist at an unlikely place called Boeing. After graduating from Seattle Community College, Mitsui worked at the airplane manufacturer drawing screws and scaffolding. Eventually, he worked his way up by doing slide shows on a "Genigraphics" computer which earned him a spot on the graveyard shift. This enabled Mitsui to do freelance work during the day, though he slept very little during this time. He eventually quit Boeing and began to work for a friend at Magicmation doing corporate presentations. He then went on to co-found Studio M.D. and the rest he says, "is history."

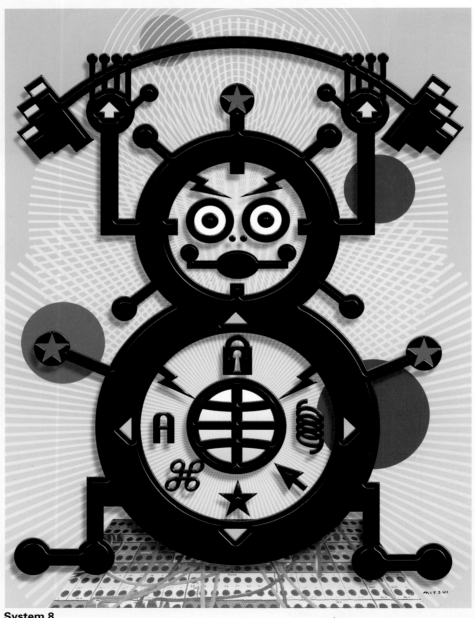

System 8
MacWorld: Editorial illustration
Software: Freehand, Alien Skin

VISIO. TECH
Visio Corp.: Software package illustration
Software: Freehand

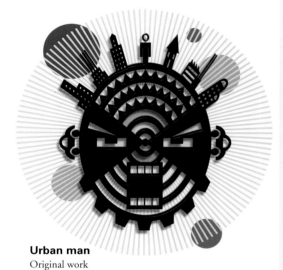

Urban man
Original work

A°CINO

Woman
ACINO: Promotional postcard

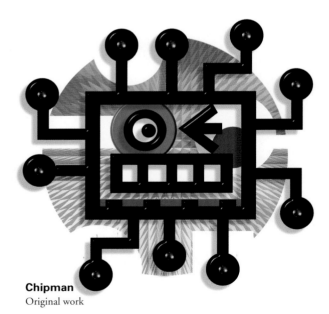

Chipman
Original work

Left
BusinessWeek
BusinessWeek magazine: Editorial illustration
Software: Painter

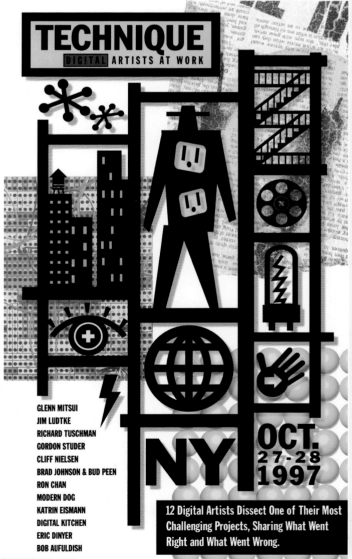

TECHNIQUE
DIGITAL ARTISTS AT WORK

GLENN MITSUI
JIM LUDTKE
RICHARD TUSCHMAN
GORDON STUDER
CLIFF NIELSEN
BRAD JOHNSON & BUD PEEN
RON CHAN
MODERN DOG
KATRIN EISMANN
DIGITAL KITCHEN
ERIC DINYER
BOB AUFULDISH

NY OCT. 27-28 1997

12 Digital Artists Dissect One of Their Most Challenging Projects, Sharing What Went Right and What Went Wrong.

TECHNIQUE. NY
Thunder Lizard Productions: Poster Design for "Technique Conference"
Software: Freehand

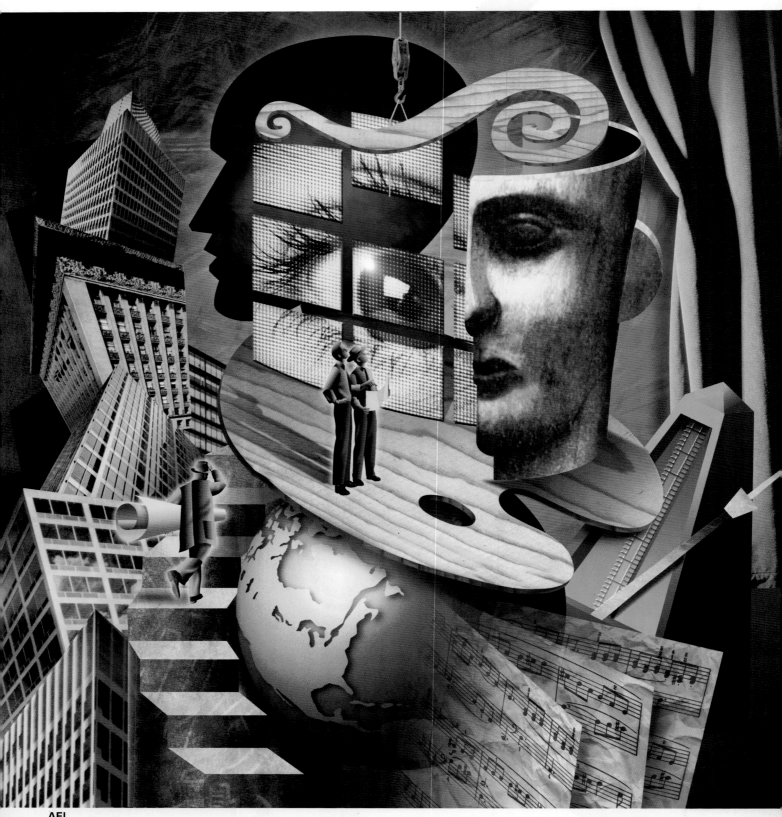

AEI
AEI: Illustration for video wall

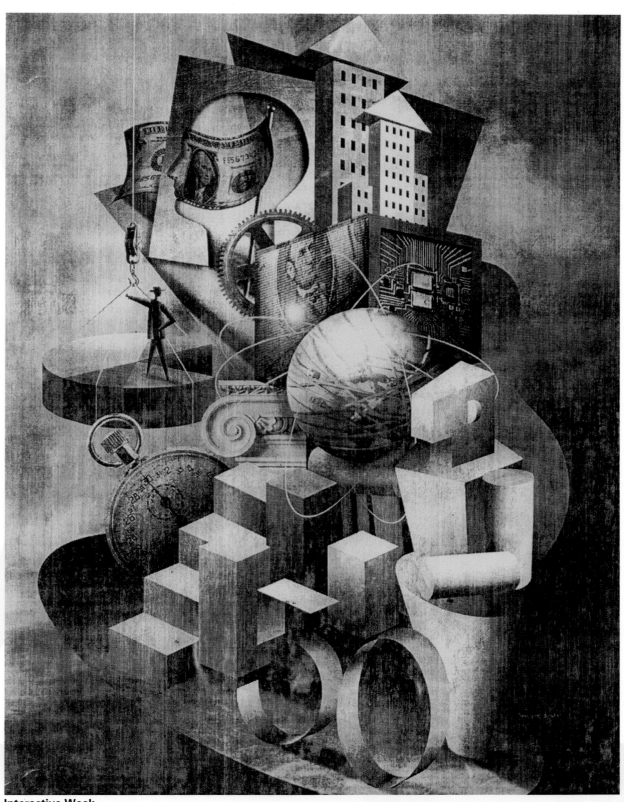

Interactive Week
Interactive Week: Editorial illustration

Andy Hickes

Andy Hickes practices architectural illustration in Manhattan, specializing in fine electronic renderings. Born and raised in rural Pennsylvania, Hickes earned a Bachelor of Architecture degree from Carnegie-Mellon University, and opened his architectural rendering business in 1978. An active member of the city's professional community, Hickes founded the New York Society of Renderers in 1985. His clients have included The Walt Disney Company, Robert A.M. Stern and Trump Casino. Hickes created all of the images featured here with an Apple Macintosh.

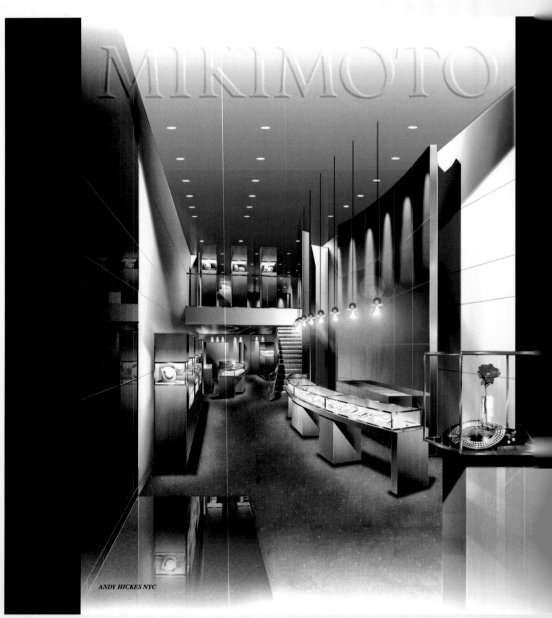

Mikimoto Pearls
Takashimaya Design: Architectural illustration
Software: Autocad

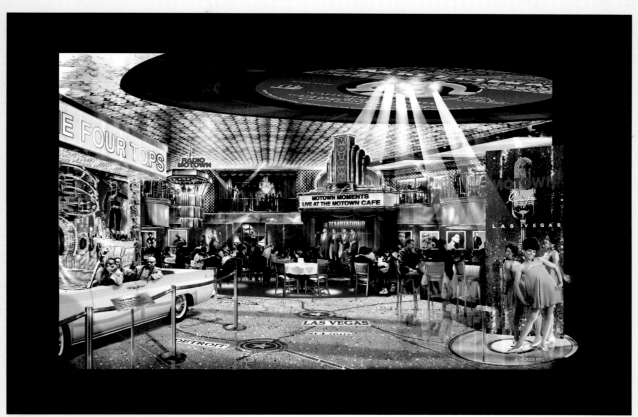

Motown Cafe Theme Restaurant, Las Vegas
Haverson Architecture and Design: Architectural illustration

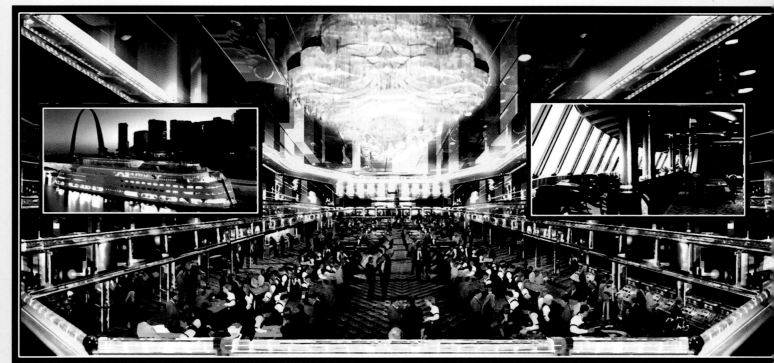

Mississippi Riverboat Casino, St. Louis
Presidential Casinos Inc.: Architectural illustration

Right
Main Entrance View, Times Square, Multi-Use Complex, Hong Kong
Brennan Beer Gorman Architects: Architectural illustration
Software: Autocad

Estee Lauder Installation, Paris
Estee Lauder International: Architectural illustration

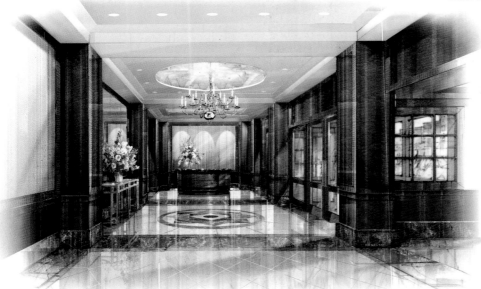

Lobby View, The Richmond Condominium, New York City
The Richmond Corporation: Architectural illustration

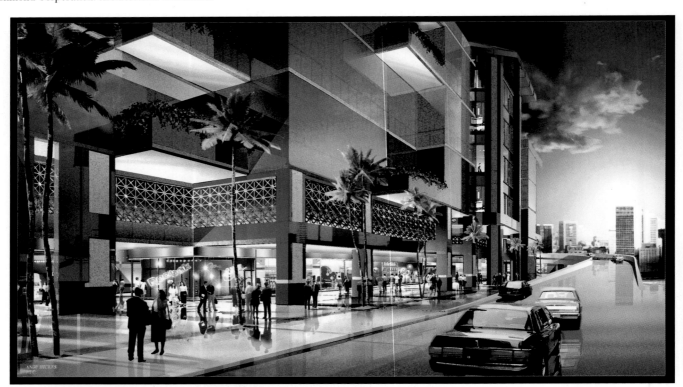

Street Level View, Times Square, Multi-Use Complex, Hong Kong
Brennan Beer Gorman Architects: Architectural illustration
Software: Autocad

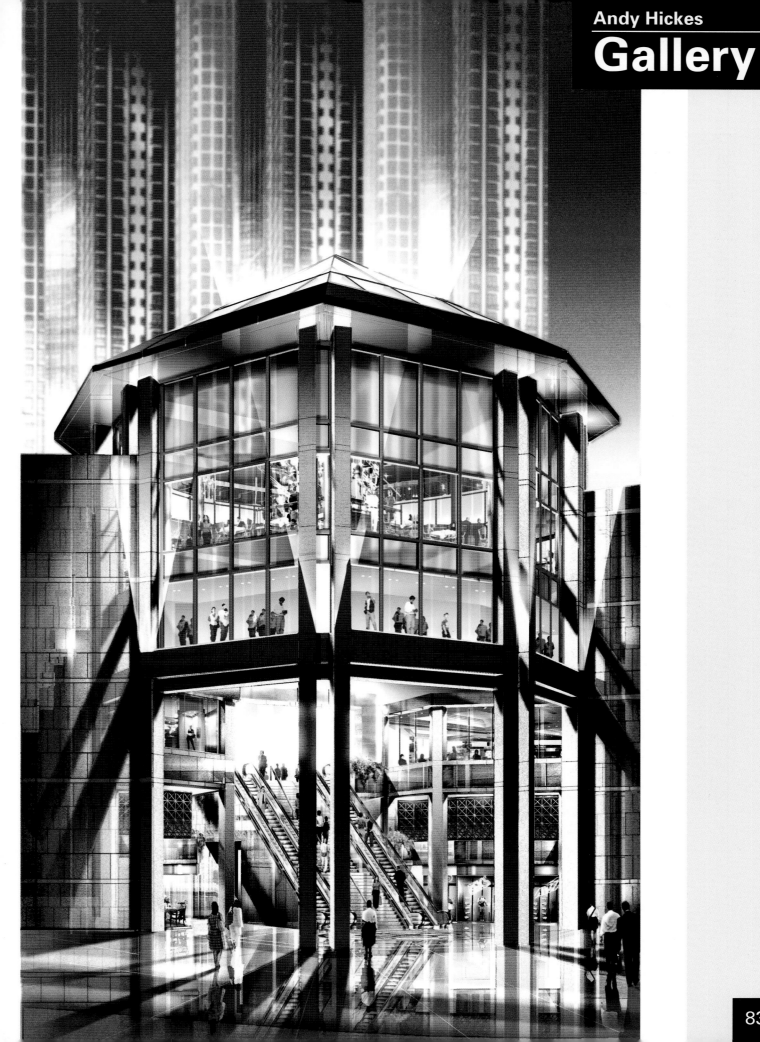

Locomotion Promotion

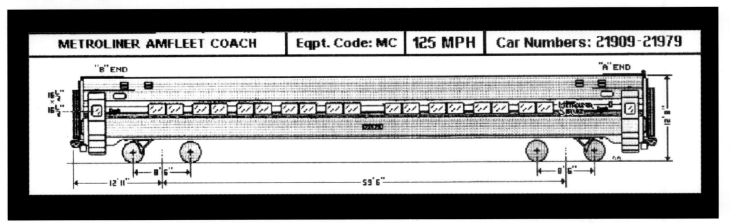

METROLINER AMFLEET COACH	Eqpt. Code: MC	125 MPH	Car Numbers: 21909-21979

Assignment

Create three designs to be used on the side of a train car as a "movable resource" for product promotion. The train could be moved around the USA to capitalize on specific events linked with the product. The three events to be illustrated were: a James Bond movie preview, the Super Bowl, and Mardi Gras in New Orleans. The client usually relied on marker sketches at this stage, but I realized it would be more efficient for me to do sketch collages in *Photoshop*. I could create one generic train car image that could be manipulated and decorated to show the above three themes.

①-A

①-B

①-C

Step 1

Using photos I took of the interior of an existing train car, I created a floor to ceiling section showing one window. This was multiplied horizontally to create the full length of a train car. The floor area was selected with a lasso tool and filled with a soft gradient. Noise was added to simulate a carpet texture. In Quick Mask mode, I created and filled overlapping ellipses of various sizes. Gaussian Blur was used at 5 pixels on the mask to create soft edges. Using this mask and the dodge tool, I created spots of light of the carpet (see fig. 1-A thru 1-C).

Step 2

I scanned photos of a chair and several stools. After removing the backgrounds, I multiplied and transformed them to the correct size and grouped them on another layer over the floor. The seating bolsters were created using gradations in rectangular selections. Diagonal strokes with the dodge and burn tools were used to add highlights and shadows. The metallic bar is a multiple gradation inside another rectangular selection. The bar top is another selection filled with a wood tone. All are given highlights and shadows using the dodge and burn tools freehand (see fig. 2-A thru 2-C).

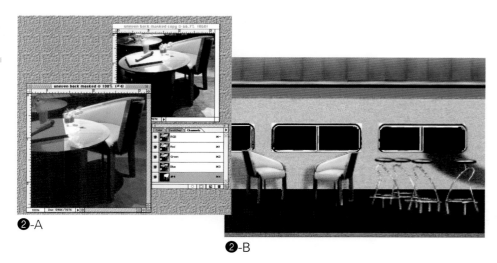

②-A

②-B

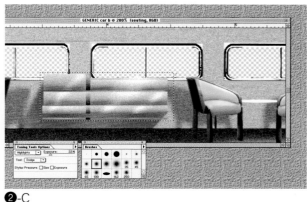

②-C

③-A

③-B

Step 3

I opened a new file to create the chandelier. Using a cocktail glass-shaped selection, I painted a single glass with the airbrush tool. Multiplying and transforming this single glass, and overlapping the resulting glasses produced the cocktail glass chandelier. Selecting All, I used Select > Modify > Border at 9 pixels and filled it with white on a new layer. I put this layer beneath the chandelier and adjusted the transparency until it appeared to glow. I merged the two layers and randomly highlighted with the dodge tool set to Highlights to add more sparkle (see fig. 3-A thru 3-C).

③-C

Step 4

For the black and white ends of the train car, I used the scanned exterior elevation ends and filled them with the gradient tool set to Multiply. Using the Color Balance command, I put warm colors into the highlights and cool colors into the shadows to increase the illusion of reflectivity. I copied the exterior ends onto another layer over the car interior and furniture. I erased the inside edge with the eraser tool in Airbrush mode to have it fade in to the car interior (see fig. 4-A thru 4-C).

❹-A

❹-B

❹-C

Step 5

From another scanned exterior photo, the wheels of a train were masked and copied to a new layer. Using the transform tool in Perspective mode, I took the wheels out of perspective. I then copied the wheels to a new layer on the base car drawing (see fig. 5-A and 5-B).

❺-A

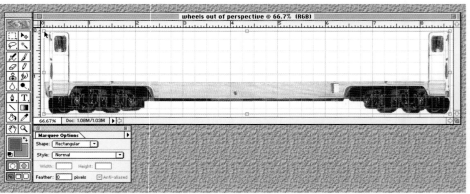

❺-B

Step 6

These layers were flattened to create the generic car. Using the Hue/Saturation command with Colorize checked, the wall and carpet layers were changed to match the different graphics for the three themes. The large wall graphics were added behind the bar. Details relevant to the specific themes were added to the respective drawings (see fig. 6-A thru 6-D).

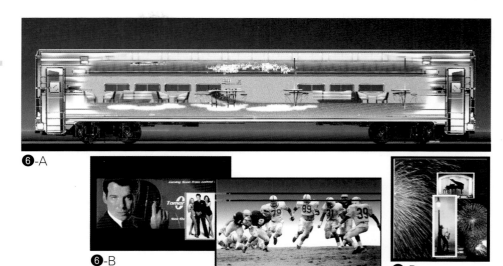

❻-A

❻-B

❻-C

❻-D

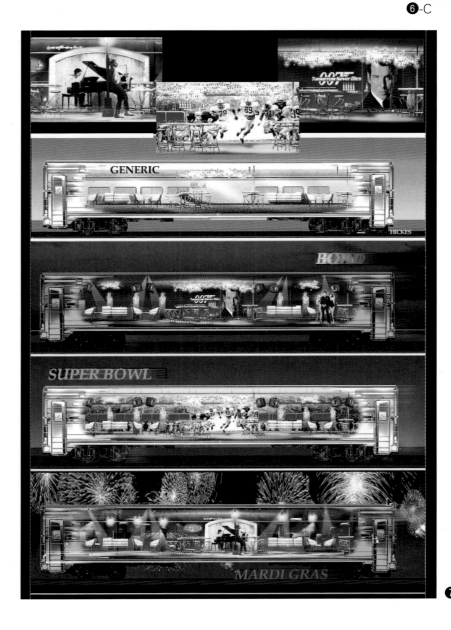

❼

Step 7

Each of the four images: the generic train, the James Bond, the Super Bowl, and the Mardi Gras train cars were printed on separate 11x17 Iris Prints; 150 dpi was used throughout. The individual train car prints were taped together lengthwise. This was folded accordion style, and presented on the Board of Directors conference table (see fig. 7).

Michael Strassburger

Michael Strassburger co-founded the Seattle-based design studio, Modern Dog in 1987. Among his recent clients have been Converse, K2 Snowboards, MCA Records and the Seattle Repertory Theatre. His career in design started at the ripe old age of seven, when he began designing posters for his own magic shows. His work is currently represented in the permanent archives of the Cooper-Hewitt National Design Museum as well as in the Museum Fur Kunst und Gewerbe in Hamburg, Germany. He has also received recognition for his work from Graphis Posters, AIGA, American Center of Design and *Communication Arts* magazine.

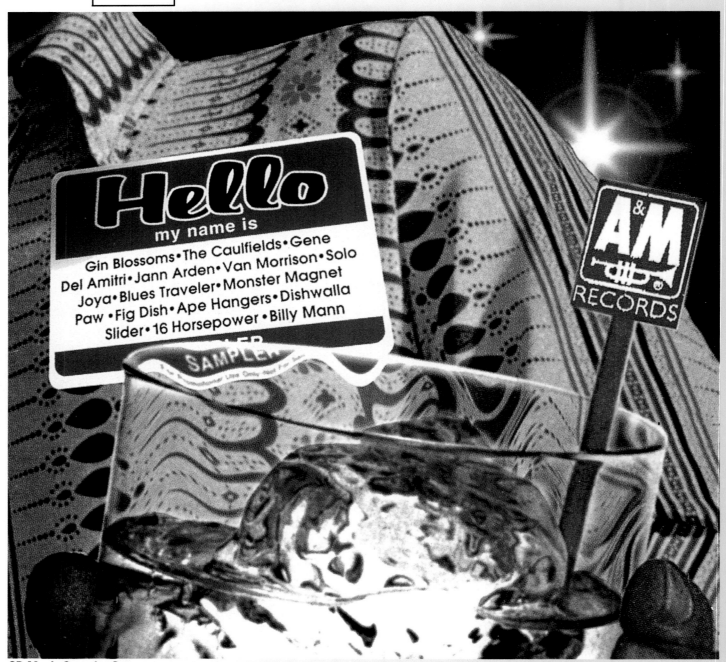

CD Music Sampler Cover
A & M Records: Music CD sampler cover

WE'D BE INSANE TO

GUARANTEE
YOU'LL BE AS GOOD AS
WAYNE GRETZKY!!

WE'D BE OUT OF BUSINESS IN A WEEK IF

EACH PAIR
WAS
HAND-SEWN
BY THE
GREAT ONE
HIMSELF

IF YOU CLIMB UP ON SOMETHING HIGH

PEOPLE WILL
LOOK
UP TO
YOU!

These shoes may not necessarily make you rich and famous, but wouldn't it be great if you did become rich and famous while you were wearing them!

YOU'LL
GET
RICH!
IF YOU WIN THE LOTTERY

Wayne Gretzky Street Hockey Shoes

LA GEAR

Warning: Shoes not shown actual size or in proper proportion to Wayne Gretzky.

©1995 L.A. Gear, Inc.

LA Gear "Wayne Gretzky" Ad for TBWA Chiat/Day
LA Gear: Advertisement for TBWA Chiat/Day

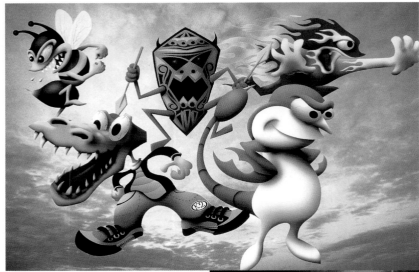

Various Ski Model Characters
K2 Japan: Ski model characters

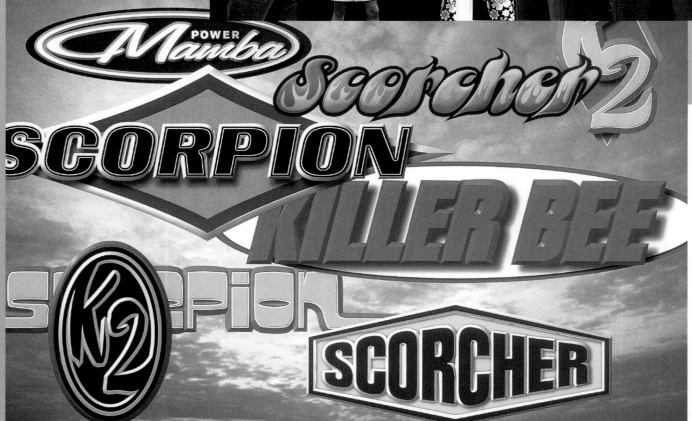

Various Ski Model Logos
K2 Japan: Ski model logos

'97-'98 Morgan Pro Model Snowboard
K2 Snowboards: Snowboard design illustration

'97-'98 Morgan Pro Model Snowboard
K2 Snowboards: Snowboard design illustration

Louis Fishauf

Louis Fishauf is co-founder and creative director of Reactor Art & Design in Toronto. Since 1986 when he was introduced to the Macintosh, Fishauf has been an enthusiastic advocate and practitioner of electronic technology in design. In 1997 he was invited by Apple Computer to become one of the first 100 AppleMasters, an "international group of recognized visionaries from various fields". He graduated from the Ontario College of Art in 1972, and apprenticed with typographer Les Usherwood, before beginning a career as an editorial designer and art director. In his thirteen years in magazine publishing, he has won numerous awards including five Gold and two Silver National Magazine Awards for art direction and cover design. He currently works from his home studio in Kettleby, a small village 40 miles north of Toronto, dividing his time between design projects and illustration commissions.

CONTINUOUS REPLENISHMENT
IBM/Principal Communications: Illustration for a corporate brochure
Software: Illustrator

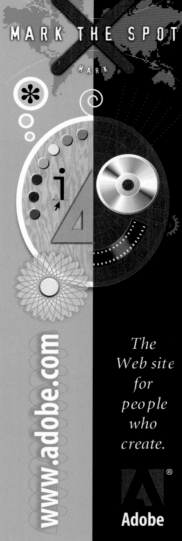

X MARKS THE SPOT
Adobe Systems: Bookmark
promoting the Adobe Systems
website.
Software: Illustrator

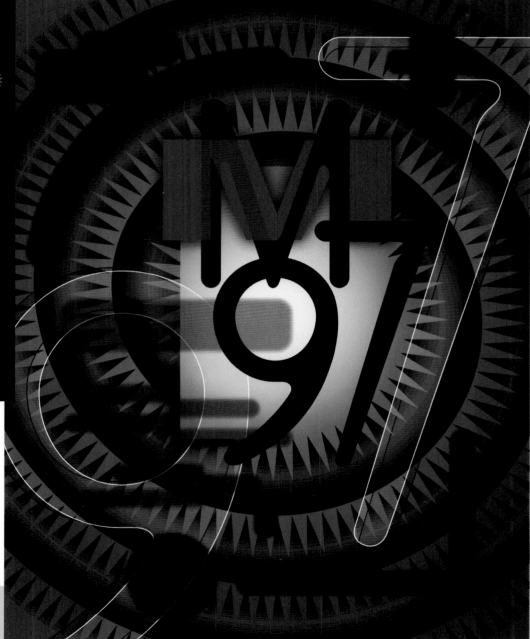

MULTIMEDIA 97
Multimedia Tradeshows: Promotional graphics for an annual tradeshow and conference
Software: Illustrator

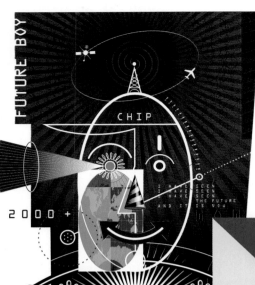

FUTUREBOY
Adobe Systems: Advertising campaign
Software: Illustrator

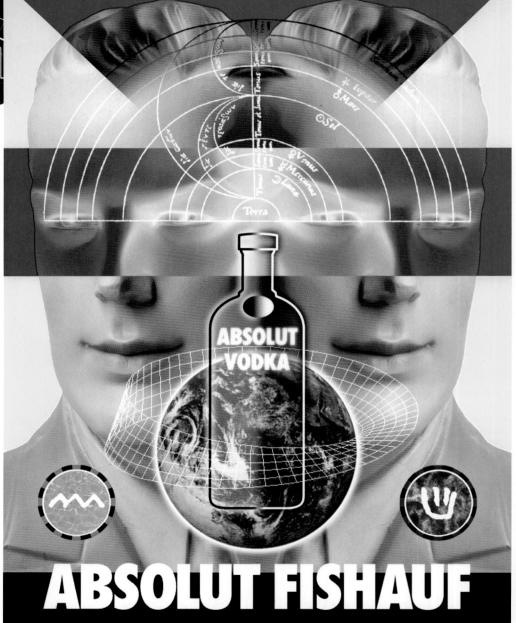

ABSOLUT FISHAUF
Absolut Vodka/*Azure Magazine:* Advertisement illustration
Software: Illustrator

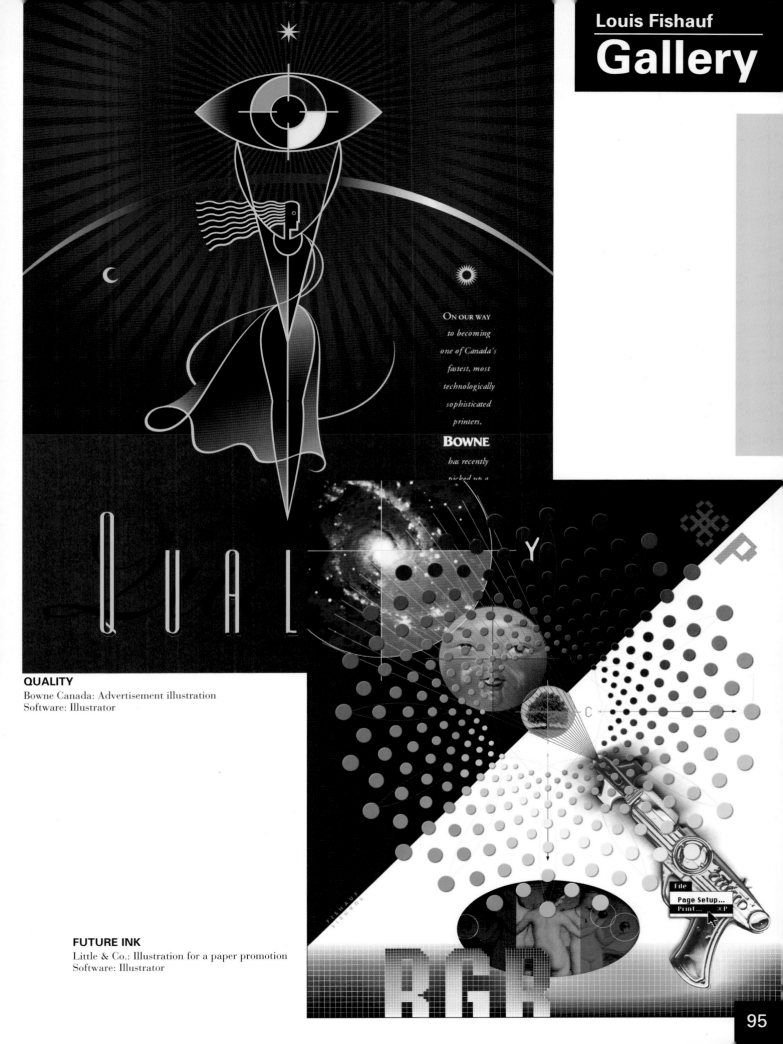

ON OUR WAY
to becoming
one of Canada's
fastest, most
technologically
sophisticated
printers,

BOWNE

has recently
picked up a

QUALITY
Bowne Canada: Advertisement illustration
Software: Illustrator

FUTURE INK
Little & Co.: Illustration for a paper promotion
Software: Illustrator

File
Page Setup...
Print... ⌘P

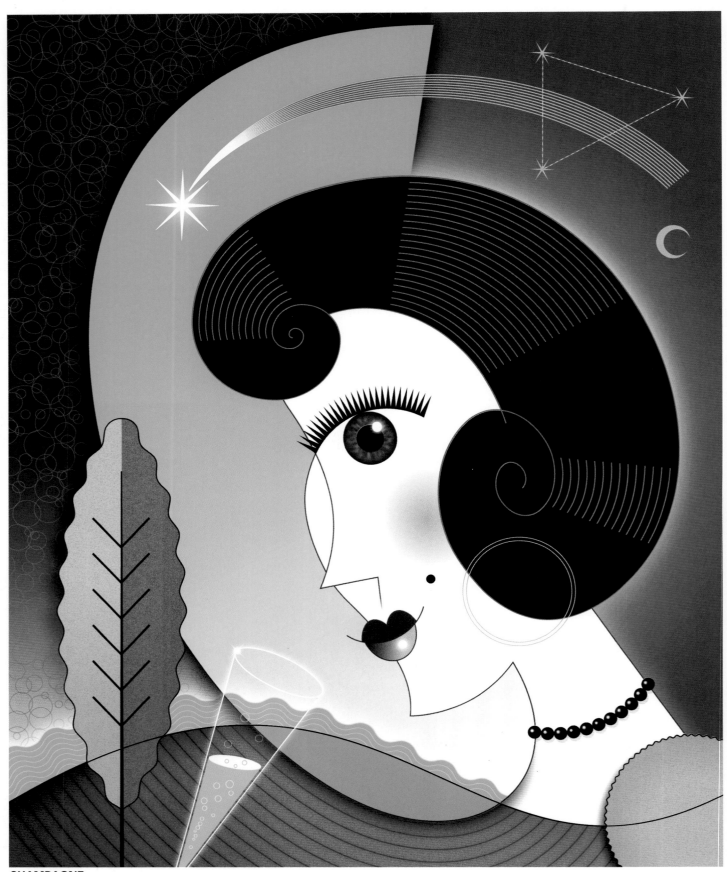

CHAMPAGNE

Computer Artist: Illustration for a magazine cover
Software: Illustrator

Mazes to "Champagne"

Assignment

Create an illustration for the cover of *Computer Artist* magazine. When *Computer Artist* magazine ran a profile on me in their August/September 1996 issue, they asked for an illustration to be used on the front cover. I had the option of adapting an existing piece or creating something entirely new. Since I seldom get the opportunity to do a purely self-directed illustration, I opted for the latter. In this case, the idea for the image came from a game that I sometimes played with my son Jackson who was 5 years old at the time. One of us would draw a maze, which the other had to navigate. The goal was to reach the X (or X's) that marked your final destination.

Step 1

One of Jackson's mazes (see fig. 1-A) suggested to me the image of a woman's head encircled by stars. I scanned the drawing and used it as the basis for my *Computer Artist* cover. Importing the scanned drawing into *Illustrator* as a template, I used it to begin creating a rough basic design. At this stage, I worked primarily with the pen tool, drawing with unfilled strokes. Then I used the spiral tool to quickly draw the hair (see fig. 1-B).

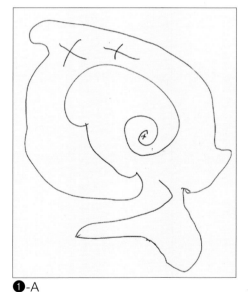

1-A

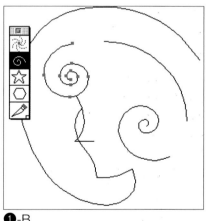

1-B

Step 2

As the illustration progressed, I began to define areas by joining the strokes and filling the resulting shapes. Between iteration 1 and 2, background elements were added, the mouth was repositioned, the head was tilted, a strong diagonal axis was created, and the woman evolved from a flaming redhead into a raven-haired beauty. As I added new elements I adjusted and fine-tuned the overall design and color palette. By iteration 3, the illustration had been further refined and most of the final elements were in place (see fig. 2).

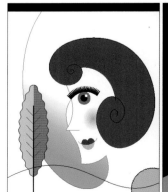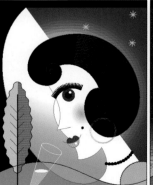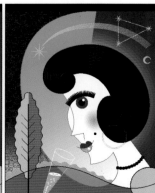

2

Step 3

To build the stylized tree, I began by creating an oval shape, which I then duplicated and overlapped. Selecting both ovals and applying the Pathfinder filter's Intersect command left only the overlapping area. The two halves of the shape were separated and individually colored. Each half was an unclosed path that has been filled and stroked. The Zig Zag filter (Filter > Distort > Zig Zag) was then applied to add the rippled edges (see fig. 3). By checking Preview in the filter's dialog box, I was able to experiment with the settings and get immediate visual feedback.

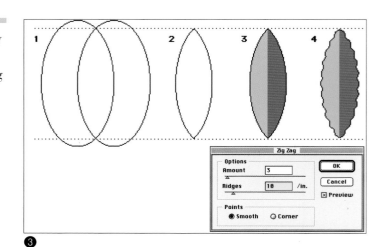

❸

Step 4

To create the wavy line pattern, I first drew a straight line. Then I applied the Zig Zag filter and duplicated the wavy line six times using Option-Shift-Drag to make the first copy, then Option-D to duplicate the transformation repeatedly (see fig. 4-A). To make the wavy line pattern follow the curve of the hillside, I used the Path Pattern filter (see fig. 4-B).

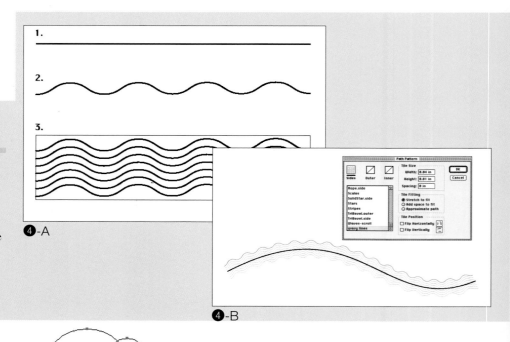

❹-A

❹-B

❺

Step 5

To create the "champagne bubbles" background, I used the oval tool to draw circles of various sizes, which I then defined as an 'Ink Pen Hatch'. This hatch was then applied to a duplicate of the background shape by using Filter > Ink Pen > Effects (see fig. 5).

Step 6

By taking the artwork into *Photoshop*, I was able to use the program's features to add subtle textures, glows, soft shadows and transparency effects that would have been difficult to achieve in a vector-based program like *Illustrator*. I began by creating a corresponding *Photoshop* file at the same physical size (in inches) and at a resolution of 240 ppi. Working with both *Illustrator* and *Photoshop* open at the same time, I began importing and rasterizing elements into the final *Photoshop* artwork. First, I imported the background, then copied and pasted individual pieces from *Illustrator* into *Photoshop* one at a time, so that each element would exist in its own layer (see fig. 6).

Step 7

I created the woman's eye in *Illustrator* out of simple geometric shapes and then copied and pasted it into *Photoshop*. Next rectangular shape was filled with the same purple color as the eye. Colored Noise was then added using Gaussian Blur. The rectangle was resized to stretch the pixels vertically. The Polar Coordinates filter was applied and the resulting texture was copied to the clipboard. The purple portion of the eye was selected with the magic wand tool, and the selection was feathered. The texture was pasted into the selected area, and its transparency was adjusted. The edge of the pupil was darkened, and as a finishing touch, the highlight was softened with the airbrush tool (see fig. 7).

Step 8

Finally all the layers except the shooting star were merged. The star was kept in a separate layer so that the *Computer Artist* logo could be easily positioned behind it. The final 2-layer CMYK *Photoshop* file was copied onto a 100M Zip disk, and sent to the magazine's art department in Nashua, NH, where the logo and cover lines were added (see fig. 8).

6

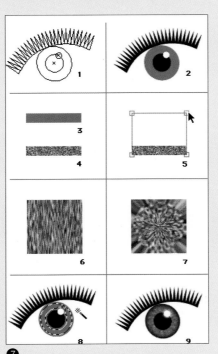

7

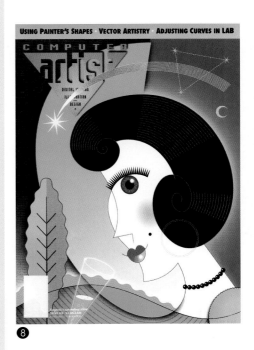

8

Susumu Endo

Susumu Endo is a graphic designer and an artist who specializes in woodblock printing. During World War II, his family moved to Hokkaido, the northernmost part in Japan, where he said that he grew up surrounded by the vast beauty of nature. After graduating from Musashino Art University, he went on to receive a degree in graphic design at the Kuwasawa Design Institute and established his own design studio. He has received many awards for his work including Grand Prix at the 2nd Bharat Bhavan International Biennial of Prints in India in 1991 and First Prize for Satirical Graphic Works at GABROVO '93 in Bulgaria. His works are on display in the permanent collections of the British Museum, The National Museum of Modern Art, Kyoto and the National Museum in Warsaw.

Horizons-4
Original work

Right
Nature 97A
Original work

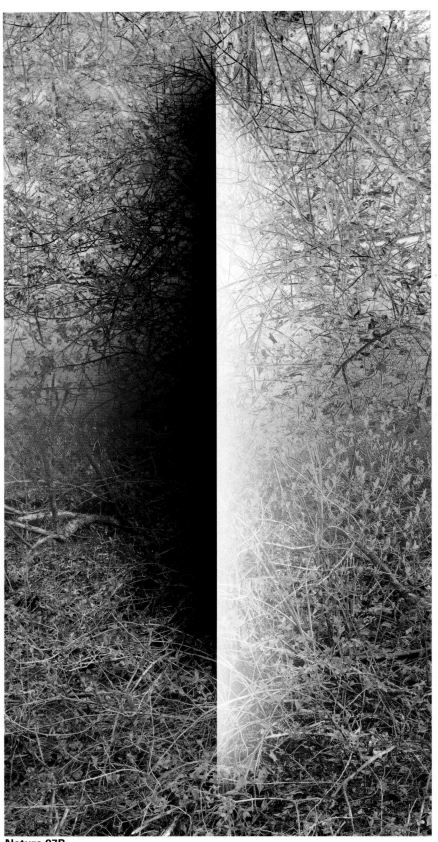

Nature 97B
Original work

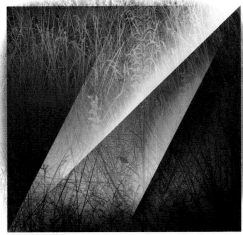

Nature 95E
Original work

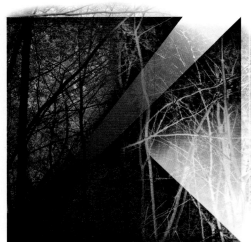

Nature 95G
Original work

Nature 94H
Original work

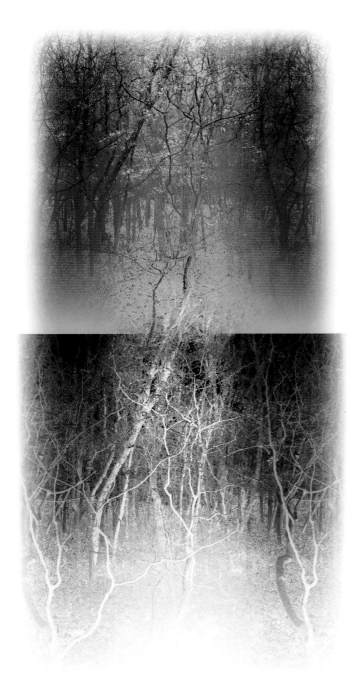

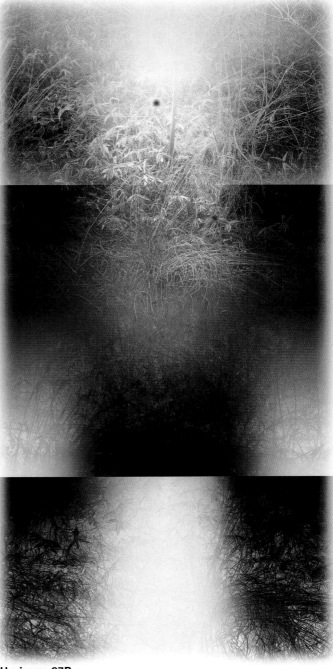

Horizons-97F
Original work

Horizons-97B
Original work

Horizons-97I
Original work

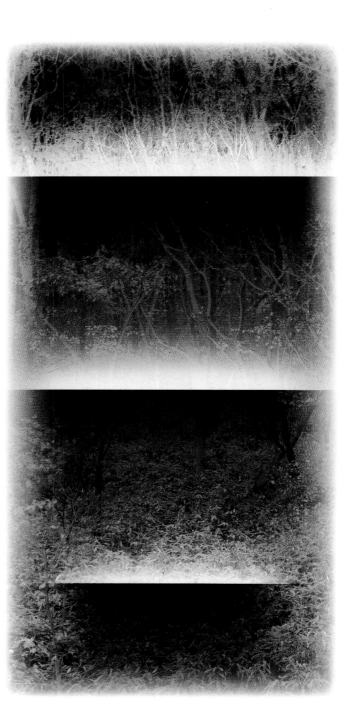

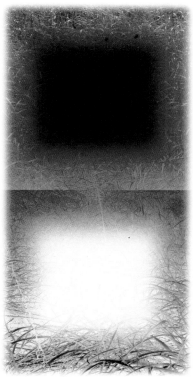

Horizons-97H
Original work

Horizons-97C
Original work

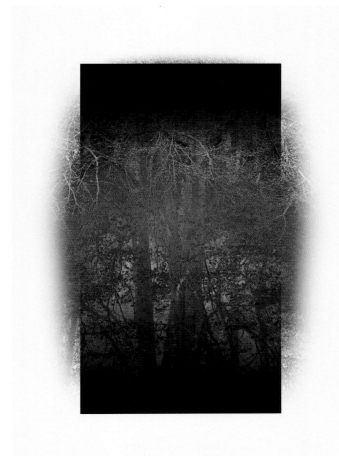

94L-1
Original work

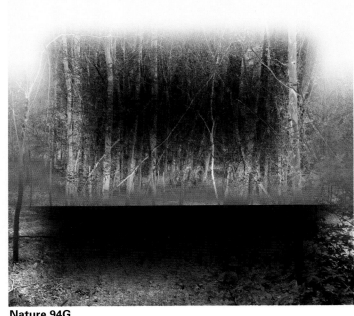

Nature 94G
Original work

Horizons-97A
Original work

Gordon Studer

Gordon Studer is a freelance illustrator who has worked out of his studio in Emeryville California for the past six years. His clients have included A.T.&T., Adobe, Microsoft, IBM, *Newsweek, Time* and the U.S. Postal Service in addition to almost every computer-related magazine. His current projects include Web pages, interactive CD-ROMs and videos as well as editorial and corporate illustrations. After graduating from Penn State University, Studer moved to Washington D.C. where he worked for a short time before traveling cross-country to Oakland, California. He began working in the Art Department of the *Oakland Tribune* newspaper and then moved over to the *San Francisco Examiner* as an illustrator/designer. It was during this time that he was introduced to computer-generated design and began developing his distinctive illustrative style.

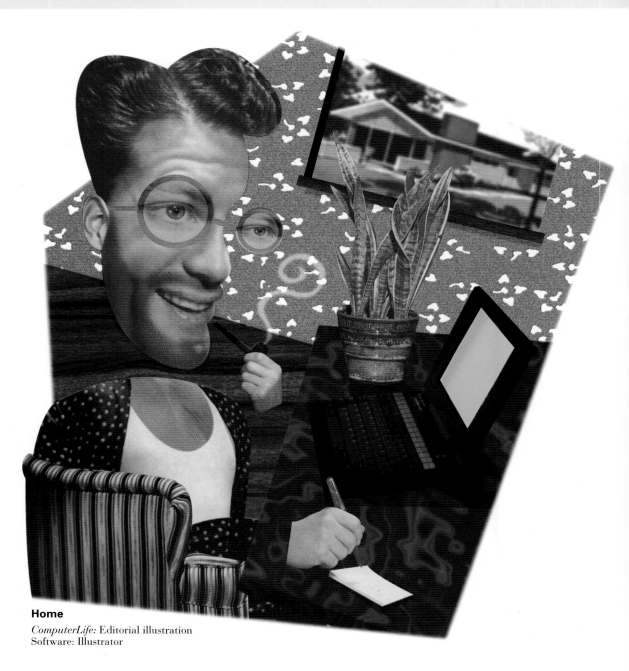

Home

ComputerLife: Editorial illustration
Software: Illustrator

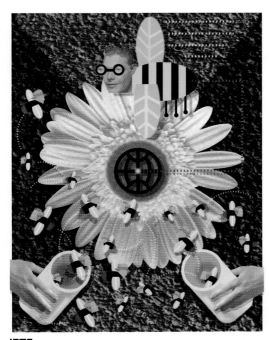

IETF
IDC magazine: Illustration
Software: Illustrator

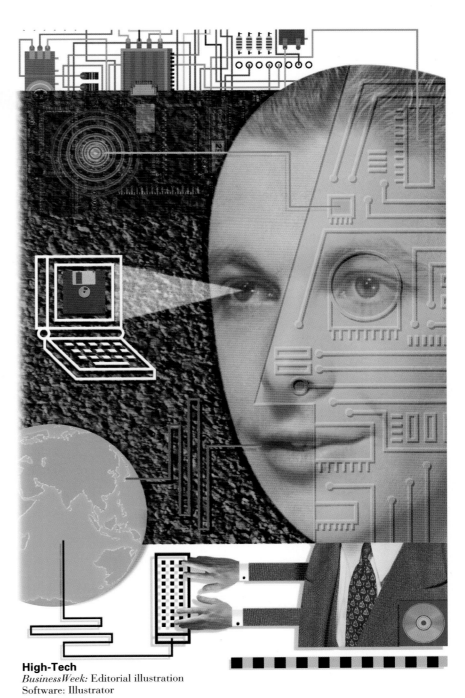

Computer Shopper
SmartMoney magazine: Editorial illustration
Software: Illustrator

High-Tech
BusinessWeek: Editorial illustration
Software: Illustrator

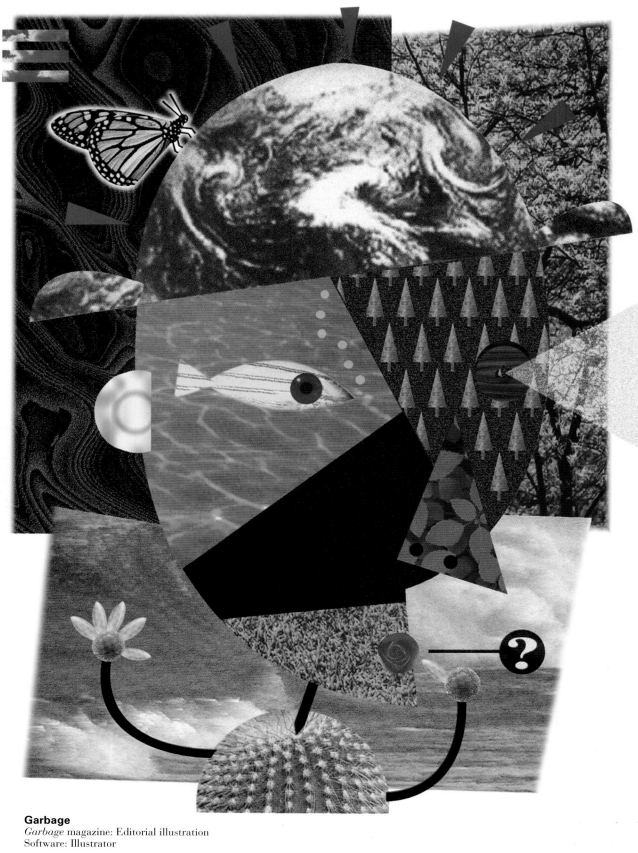

Garbage
Garbage magazine: Editorial illustration
Software: Illustrator

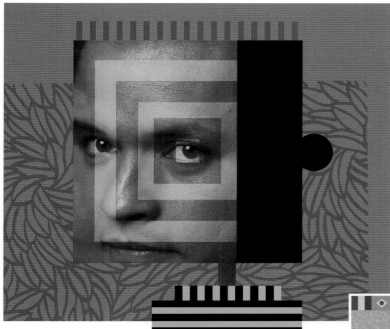

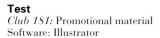

Test
Club 181: Promotional material
Software: Illustrator

Smoking
Men's Health magazine: Editorial illustration
Software: Illustrator

Currency
Wordperfect magazine: Editorial Illustration
Software: Illustrator

E-mail
MacWorld: Editorial illustration
Software: Illustrator

Cats
CIO magazine: Editorial illustration
Software: Illustrator

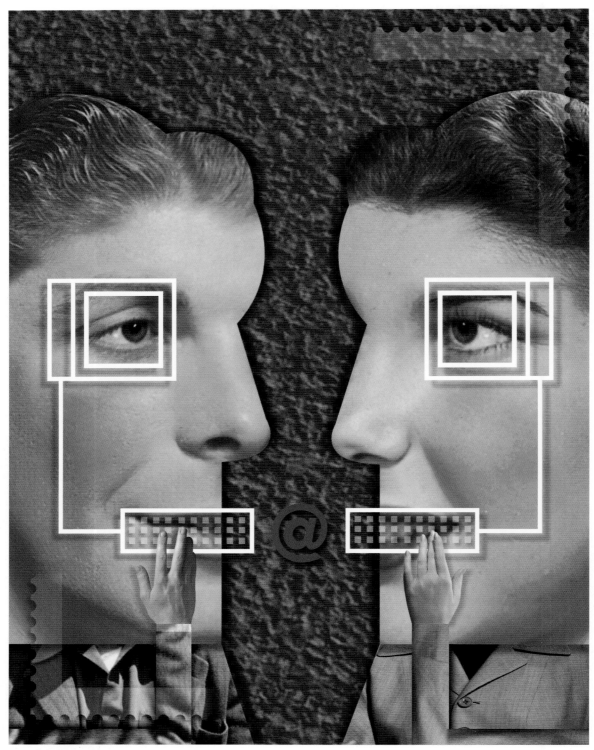

E-mail for Cover
San Francisco magazine: Cover design
Software: Illustrator

Let Your Fingers Do the Talking

Assignment

Make an illustration cover for an article about e-mail. The composition needed to convey how the use of e-mail has changed the way people relate to each other. Since the magazine had come under new ownership, they were very concerned about how the first cover under their direction would represent their new image. This was to be the first illustration used for the cover design so there was a lot of pressure to create something visually successful.

Step 1

I created a simple line sketch of the cover illustration in *Illustrator*, indicating space for the magazine masthead and bar code. The final illustration would consist of photographs, photo textures and drawn graphic objects (see fig. 1).

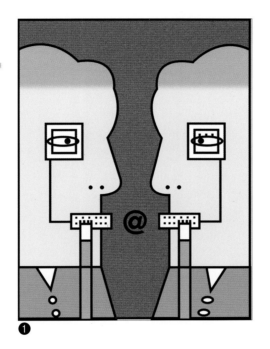

❶

Step 2

For the background image I decided to use cork board which I scanned into the image and converted into grayscale mode. Returning to RGB mode, the image was then colorized, using the Color Balance command. I used the Gaussian Blur filter set to 4 pixels and added noise with the Noise filter set to level 20 (see fig. 2).

❷

Step 3

All photographs for this illustration are from PhotoDisc's *Retro Americana* CD. Since they were taken by the same photographer, the parts selected for the illustration maintained a consistency critical to the composition as a whole. When choosing the photographs to be used for the head images, it was important to choose images with similar lighting and photo quality. In this case, larger studio shots were useful as detail was important (see fig. 3-A through 3-D).

❸–A

❸–B

❸–C

❸–D

Step 4

The photo was flipped horizontally and the top of the head was selected with a 5 pixel feather. The image was copied, pasted (creating a new layer) and moved down into the lower forehead area. The same process was used on the mouth image. The images were converted from grayscale mode into RBG. An eye was pasted in from another photo, adjusting for size, brightness and contrast, then feathered to blend it into the face. The face layers were colorized, using Image > Adjust > Color Balance (see fig. 4-A and 4-B).

❹–A

❹–B

112

Step5

Once the image had been colored, the pen tool was used to define the desired shape within the photo to be loaded as a selection. I copied and pasted the head shape onto the background layer, then moved and scaled the selection into position (see fig. 5-A and 5-B).

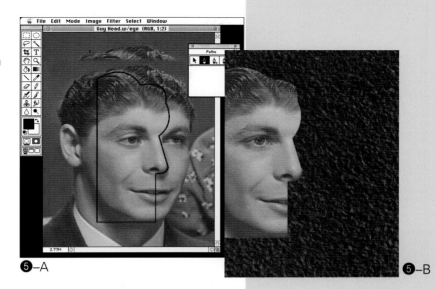

5–A **5**–B

Step6

To make a drop shadow for the head shape, I copied the image and pasted it into another layer. Then I selected the copied image and filled it with black using a 10 pixel feather. The feathered image was placed beneath the background layer, creating the shadow (see fig. 6).

6

Step7

To create the opposing head image, I selected a woman's head from a scanned photograph, flipped it horizontally and placed it in a layer above the background layer. The opacity was reduced so the images on both layers could be seen. Using Layer > Transform > Scale, the size of the woman's head was adjusted to match that of the man's head and cut to shape (see fig. 7-A and 7-B).

7–A

7–B

Step 8

The woman's head was flipped, merged with the background and color-adjusted. The same alterations that were made to the man's head were also made here, such as lowering the hairline and mouth and increasing the eye size (see fig. 8).

Step 9

After selecting and copying the body images from the scanned originals, I colorized the bodies and pasted them into the composition, repeating step 6 to create the drop shadows behind the body images. The document was saved and then saved again under a different file name in EPS mode at low-resolution (see fig. 9).

Step 10

In *Illustrator*, I selected the Place Art command from the File menu and opened the low-res EPS file I had just created to use as a guide. After positioning the objects and finishing the line drawings in *Illustrator*, I deleted the placed image and saved the line drawings as EPS *Illustrator* files (see fig. 10).

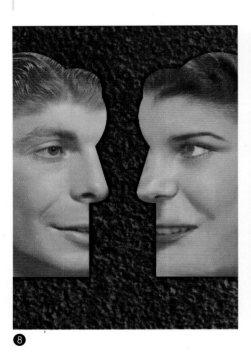

❽

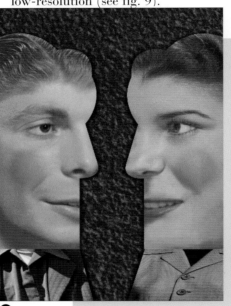

❾

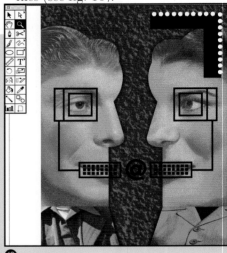

❿

Step 11

I opened the *Illustrator* document in *Photoshop* and adjusted the dpi to 300 to match the main image. Selecting the objects with the magic wand tool, I copied and pasted them into the main image, filled them with white and created drop shadows. The computer keys were copied and pasted into position and the opacity reduced to 40% so that the mouth could be more clearly viewed (see fig. 11-A and 11-B).

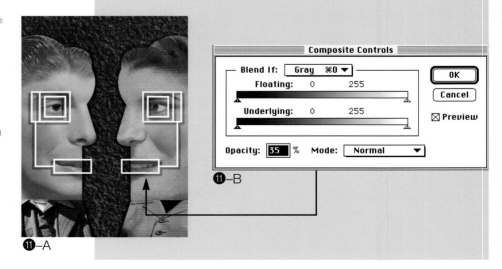

⓫–A

⓫–B

Step 12

After the final *Illustrator* images were imported, the "@" symbol was filled with red and given a drop shadow. The image of the stamp edge was filled with white and made semi-transparent by lowering the opacity to 25% while the edges were using a feathered. I selected the hand images from the *Retro Americana* CD, copied them into the composition and created drop shadows. The ring on the woman's hand was removed using the rubber stamp tool with Clone option (see fig. 12-A and 12-B).

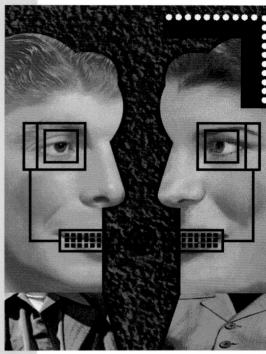

⑫–A

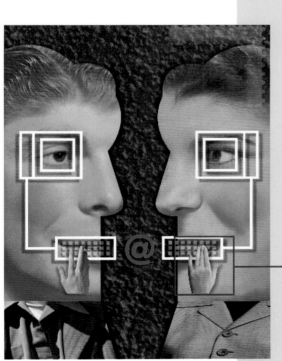

⑫–B

Step 13

Selecting the arms from the original scanned photographs, I copied and pasted them into the composition and made the final adjustments to the piece (see fig. 13).

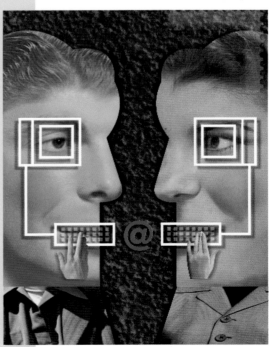

⑬

Sharon Steuer

Sharon Steuer is an artist and illustrator living in Bethany, Connecticut. Since 1983, Steuer has produced computer illustrations and animations for clients including IBM, Apple, American Express, Travelers Insurance, and Letraset. Her work has appeared in magazines such as *American Artist*, *Create*, *MacWeek*, *Macworld*, *Computer Artist* and *Step-By-Step Electronic Design*, and in many books, including *The Official Photoshop Handbook*, *Getting Started in Computer Graphics* and *Fundamental Photoshop*. The *Illustrator Wow!* books, which she authored, have been widely praised and her most recent edition, *The Illustrator 7 Wow! Book*, was the winner of the 1997 Benjamin Franklin Award for "outstanding computer book."

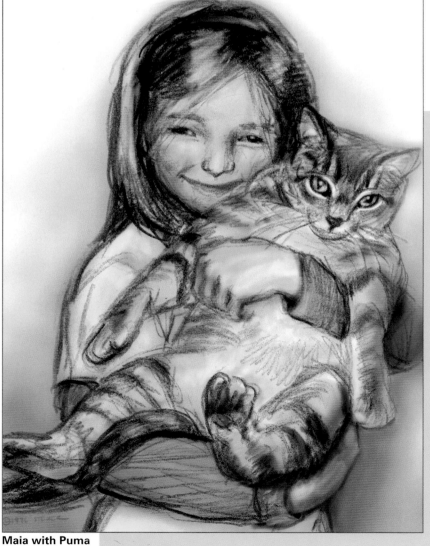

Maia with Puma
Children's book illustration (book in progress)

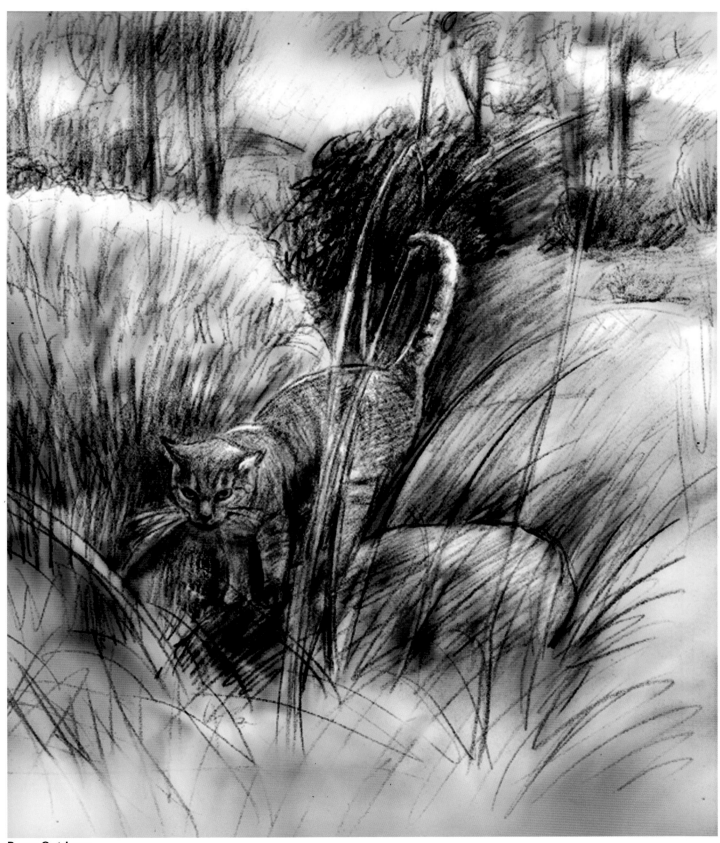

Puma Outdoors
Children's book illustration (book in progress)

New Home
Children's book illustration (book in progress)

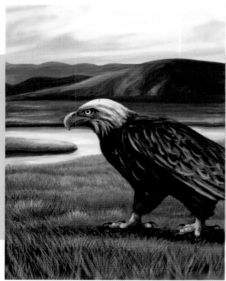

Autumn Eagle
Children's book illustration (unpublished)
Software: Painter, FreeHand

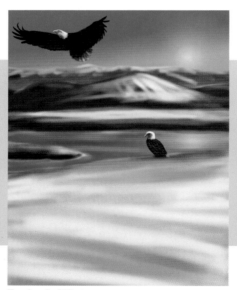

Eagles in Winter
Children's book illustration (unpublished)
Software: Painter

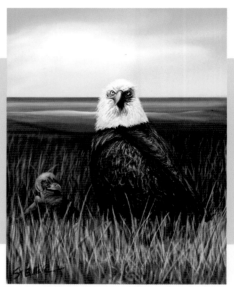

Eagle with Chick
Children's book illustration (unpublished)
Software: Painter, FreeHand

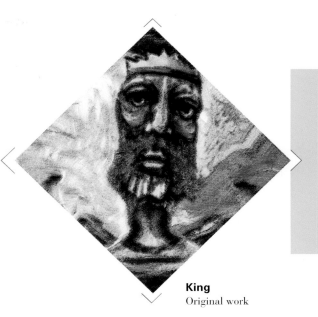

King
Original work

Dancing Figures
Original work

Mythology
Original work

Museum
Original work

Bones
Original work

119

Richard Wolfströme
The Art of Invention

Richard Wolfströme is a designer and a founding member of the multimedia design group The Art of Invention. Established in 1994, Richard and his partners have worked with both large companies as well as smaller groups and those involved with the arts. Specializing in "new-media" design projects, the group has earned accolades for their internet work and received numerous awards for their innovative digital designs. Believing that the information an image presents is paramount to the aesthetic that each piece creates, his group focuses on the interplay between narrative and imagery and on creating pieces that are both visually striking and wholly interactive. Recently, Richard and his colleagues merged with another design group called Liquid Light, taking on new director Finn Taylor, whose works also appear in this showcase.

Water Baby
Audio Visuality: Cover illustration

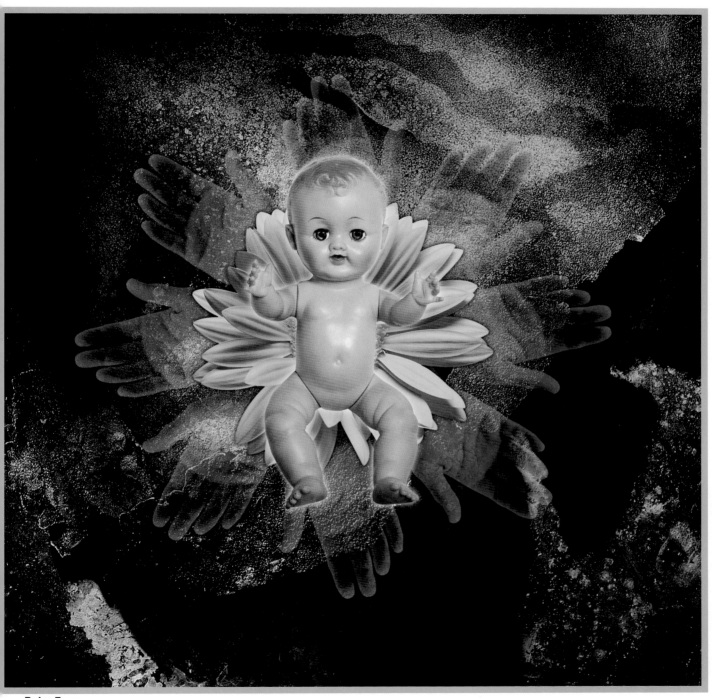

Baby Face
PhotoDisc: Advertising campaign

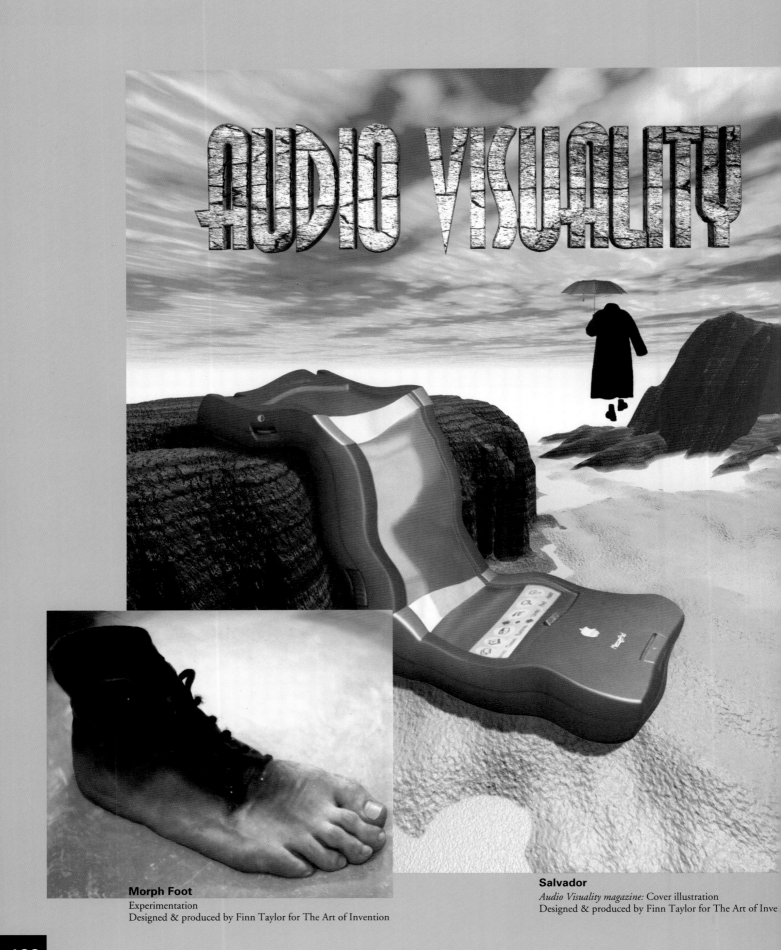

AUDIO VISUALITY

Morph Foot
Experimentation
Designed & produced by Finn Taylor for The Art of Invention

Salvador
Audio Visuality magazine: Cover illustration
Designed & produced by Finn Taylor for The Art of Inve

①

⑤

②

⑥

③

⑦

1-4. The Typographic Companion

CD-ROM interfaces for interactive program about typography
Software used: Illustrator, DeBabelizer, Premier, Sound Edit Pro, Quark Immedia
① Anatomy ② Main Menu ③ Art & Craft ④ Product Description

5-8. Donside

CD-ROM of the '1995' & '1996 Donside Graphic Design & Print Awards'
Software used: Illustrator, Infini-D, DeBabelizer, Premier, Sound Edit Pro, Macromedia Director
⑤ Button Menu ⑥ Choices ⑦ Gala Evening 1996
⑧ Winners Main Menu

④

⑧

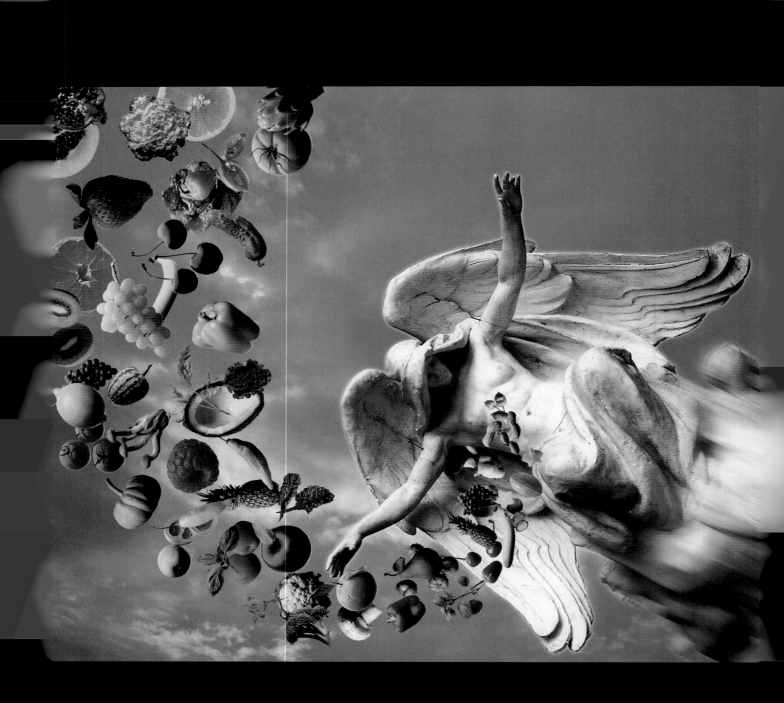

Cornucopia
PhotoDisc: Advertising campaign

There Must Be an Angel...

Assignment

Create a new image for PhotoDisc Europe for its current advertising and marketing campaign. The company stipulated that the original composition utilize images from its CD library, featuring in particular the royalty-free images from its *Object Series* CD-ROM set. The image needed to have an element of fantasy to show how far one could go with such image-based libraries. The combination of an angel and food was not an immediately obvious one, but such a bold juxtaposition provided a clear sense of the variety of material contained in the library, thus meeting the client's objective in an imaginative way.

Step 1

First, a high-res angel image was selected from the *Architectural Elements* CD included in the *Object Series* set. All images in the *Object Series* come with built-in clipping paths so importing the angel image into *Photoshop* was fairly simple. The path was chosen with the Anti-aliased option selected. The image was resized, then cut and pasted into a new document on its own separate layer so that it would have a transparent background (see fig. 1).

Step 2

The angel was rotated approximately 40° counterclockwise and set in the lower right hand area of the page. Once positioned, the image was sharpened using the Unsharp Mask filter. This brought out greater detail in the stone while also giving the image more contrast (see fig. 2).

Step 3

To give the image a sense of movement, I selected the Motion Blur filter. The lasso tool was used with a heavy feather to isolate areas of the blur, allowing the blur to vignette into the focused areas. The angle of the blur was made to coincide with the angle of the angel. This layer was called the 'Angel Blur' layer. In case any serious mistakes were made, the original unmodified angel was first duplicated and saved as a separate layer (see fig. 3).

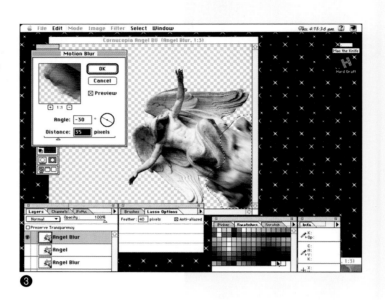

❸

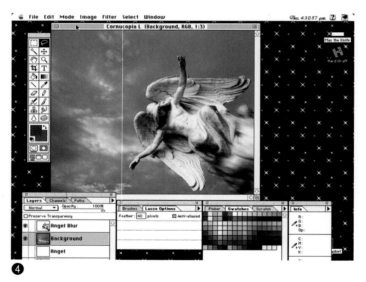

❹

Step 4

Since the angel was originally a gray scale image, the file was converted to RGB so that colored elements could be used. In order to create a "warm" feeling within the composition, a suitable sky background was selected from PhotoDisc's *Signature Series*. This was positioned as a background layer (see fig. 4).

Step 5

To create an aura around the angel, I first duplicated the 'Angel Blur' layer. The image was isolated and filled in with white. Then the whole layer was selected and the Gaussian Blur filter was used to feather the edge of the white silhouette, which by expanding the surface area, made the angel appear to glow. To make the effect more subtle, I reduced the opacity of the layer to 80% (see fig. 5).

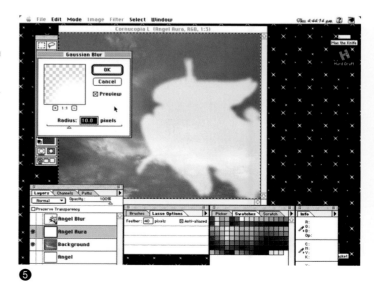

❺

Step 6

A new layer was created called 'Fruit 1'. From the *Fruits and Vegetables* CD-ROM, I selected images of various kinds of fruits and vegetables and began constructing an arc using them. During this process the elements were resized and rotated to maintain balance in the composition (see fig. 6).

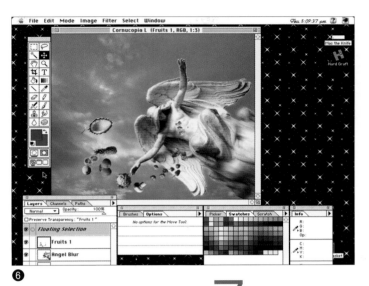

❻

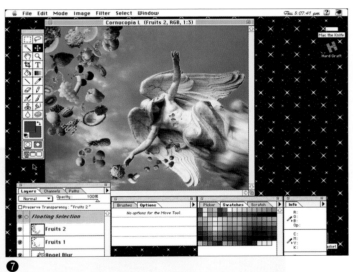

❼

Step 7

A second layer of fruits and vegetables was created and overlapped with the fruits and vegetables on the first layer. It was important not to overlap objects on a single layer so that manipulations could be made later if it became necessary. This procedure gave me the flexibility to move and rearrange the elements within the design without being constrained by merged objects (see fig. 7).

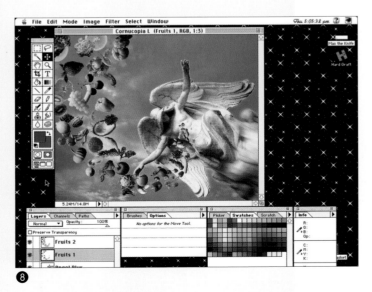

❽

Step 8

Once the image was complete, the original layered version was kept as a back-up for future revisions or changes. When converting the completed image to CMYK, the composition layers were maintained separately to allow for color correction of individual elements, which can determine how the image prints. Here Curves was used to adjust the tonal ranges of each of the separate elements. If the image had been flattened before color correction, Curves would have affected the tonal range across the entire composition and dulled the overall tonal sensitivity. Having achieved the desired effect using Curves, the composition was finally flattened and saved as a TIFF file for use in DTP packages (see fig. 8).

Russell Sparkman

Russell Sparkman is an internationally recognized artist currently living in Japan. His artwork has appeared in numerous magazines and books, including *IdN*, *The Photoshop Wow! Book*, *Computer Artist* and *Mac Art and Design*. In addition, Sparkman is one of the featured artists in the gallery section of the *Adobe Photoshop 4.0* CD-ROM. Sparkman is also highly regarded as an author and speaker about digital imaging. He is the author of *Collage with Photoshop* and the co-author of *Adobe Photoshop A to Z II* and *III*. Sparkman's most recent work is entitled *Essentials of Digital Photography*, co-authored with Akira Kosai and released in both Japanese and English.

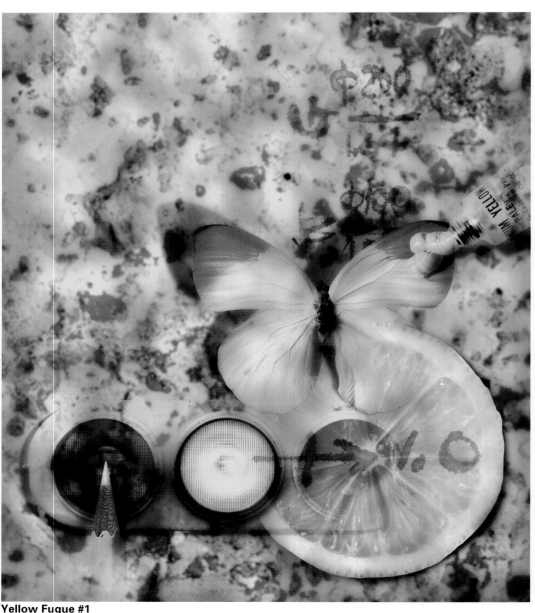

Yellow Fugue #1
Canon Corporation: Cover design for corporate magazine

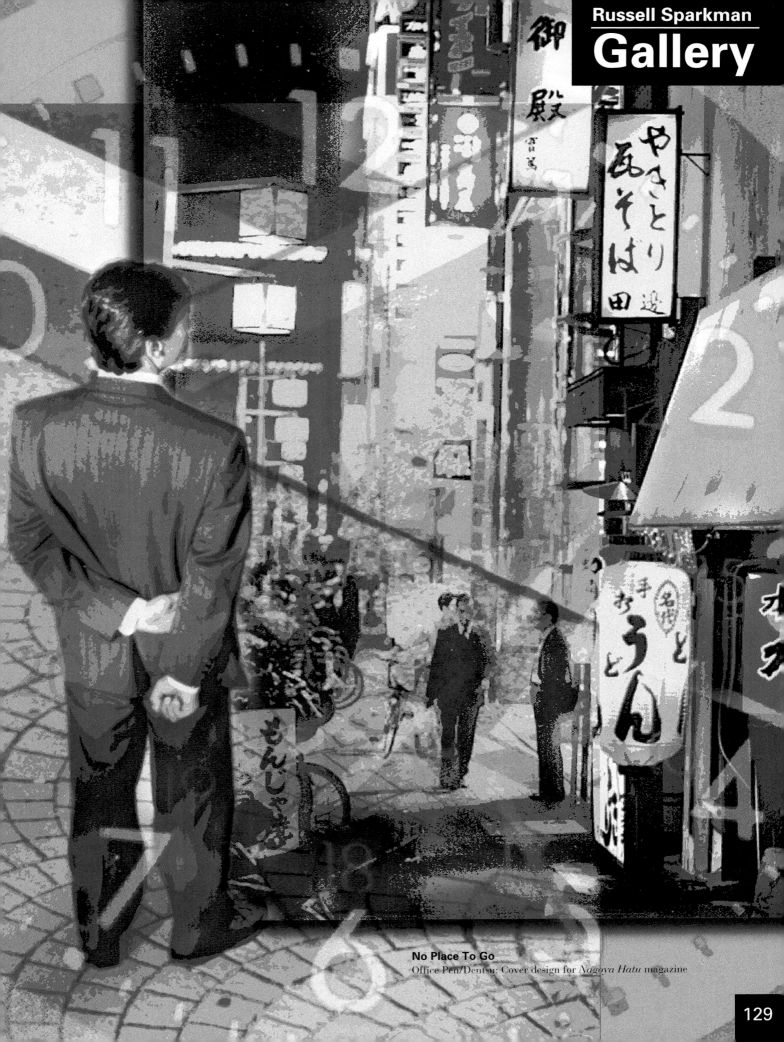

No Place To Go
Office Pen/Dentsu: Cover design for *Nagoya Hatu* magazine

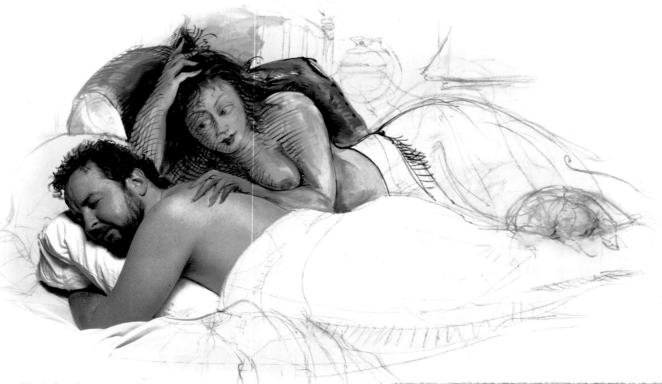

Mark Steele
Original work

The Dr. Marten Boot
D Art: Illustration art for *Essentials of Digital Photography*
Software: Painter

The Mind Seeks
MU Inc.: Illustration art for *Collage with Photoshop*

Which Way
Photoñica, Tokyo: Stock image

Street Crossing
Photonica, Tokyo: Stock image

Ruler
Image Corp: Stock image
Software: Metaflo

Numbers
Photonica, Tokyo: Stock image

Bryan Allen

Bryan Allen is currently based in New Jersey and is the co-founder of Chiselvision design studio. Allen was initially very much against "going computer," and he says that he was quite "stunned" by how well he took to it. Though working on the computer takes much of his time now, his true passion is sailing and he goes as often as his schedule allows. Says Allen, "If I had enough cash, I'd toss the computer over the side and sail away." Allen's latest project is a book about digital imaging entitled *Digital Wizardry*, due out in 1998.

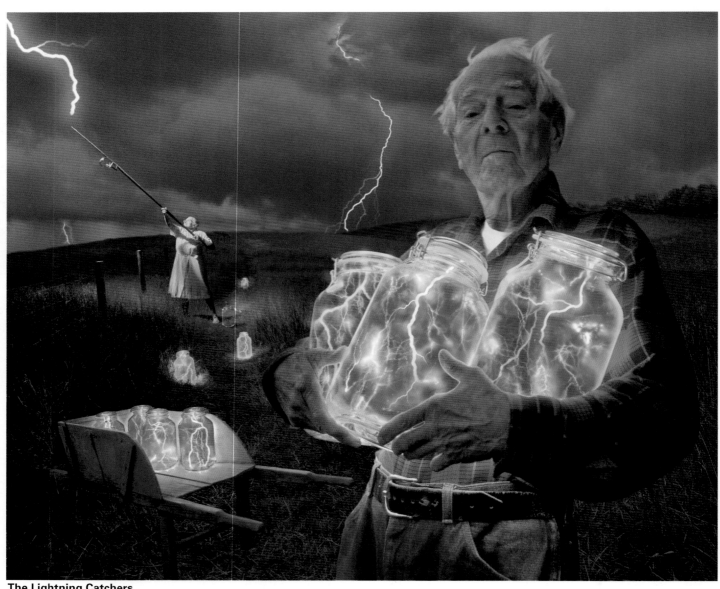

The Lightning Catchers
Self promotion: Poster

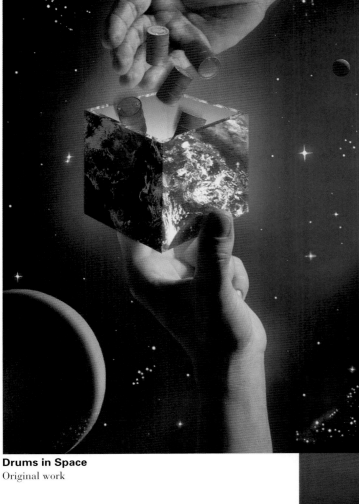

Drums in Space
Original work

First Light of the Day
Self Promotion: Print advertisement

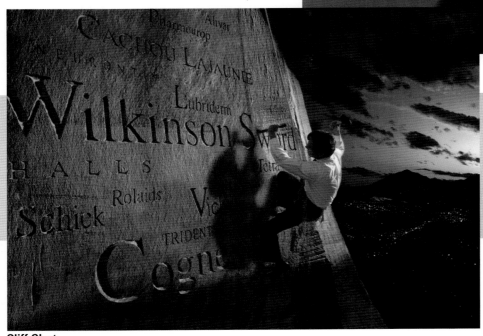

Cliff Shot
Warner Lambert: Company annual report illustration

Twilight

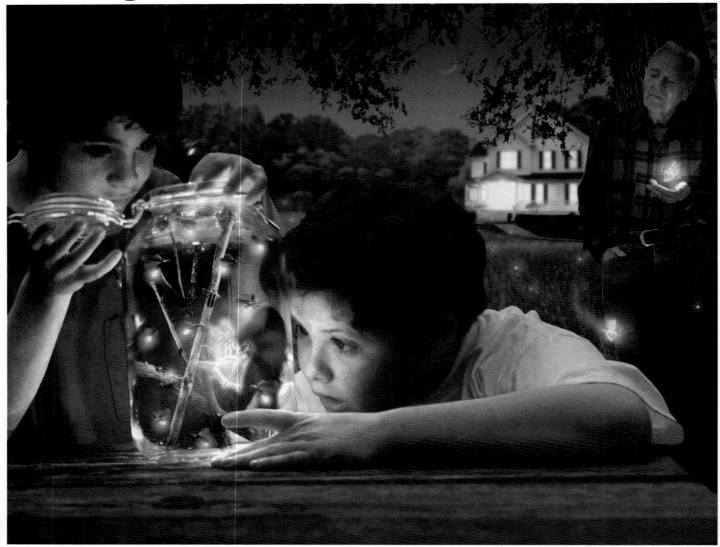

Development of the image began with concept discussions with my business partner at the time, Wayne Roth. We decided that for the image to be a success, it had to capture the "magical" quality of twilight that occurs only a few times during the summer. The image was meant not only to look but to "feel" photographic. It relied on carefully preconceived and photographed elements and a lot of adjusting so that all the elements remained consistent within the composition.

The only element not photographed specifically for this image was that of the field, which was taken from an earlier composition. The picture was taken earlier in the day than the final image would suggest but it proved to be advantageous since it gave me a great deal more creative flexibility. Had I actually photographed the field at dusk, the chrome would have had much less detail and color. I generally prefer to scan a lighter chrome with good detail and darken it down with Curves or Levels rather than scanning a darker chrome and attempting to force out all the information. On the scan of the field, Curves was used to darken the image and create the appearance of dusk. By selecting the blue channel in the Channels palette, I was able to modify the overall color to get a more bluish tone.

While the original idea for the image had the old man in front of the house with a raised oil lamp, it was decided the image lacked "intrigue." In revising, the image of the old man was placed a short distance behind the children with a few of the fairies that the children are discovering for the first time, as if he is bringing the kids into his mystical world. He also was photographed at dusk for the reasons mentioned earlier.

Since each element was shot separately, they were generally all in focus. We needed to add some selective focus back into the image and just blurring the background would not have been convincing. A more natural blur that increased into the distance was created. The Quick Mask mode was used to create a heavily feathered selection on which a Gaussian Blur was applied.

First I activated the Quick Mask mode by clicking on the Quick Mask button in the tool box. In Quick Mask mode white represents the area that allows whatever effect you apply be the strongest. Black represents the opaque part of the mask where the effect will be held back. Choosing the gradient tool set to Linear Blend, I clicked and dragged the image top to bottom, over which a red cast appeared. To turn this mask into a selection, I clicked the Quick Mask button on the left hand side. Then Gaussian Blur was applied until the desired effect was achieved.

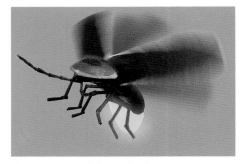

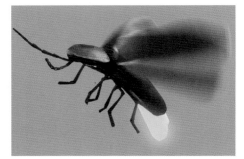

Because I could not find any sources for real fireflies to photograph I decided to build a small model of one. Though it was a bit crude, the insects would be fairly small in the image while the Motion Blur filter would be used to hide the rough edges and make them seem more lifelike. The painted clay model was photographed from many different angles and the best one was scanned in to be modified. The flapping wings were created with the Radial Blur filter and the airbrush tool was used to achieve a "phosphoring" effect.

The "phosphoring" effect is best done on a separate layer. This is what I refer to as my 'Glow' layer. With the airbrush tool set to about 12 to 15% opacity, some white or a light color is sprayed over the light sources that need the effect. For this composition, the firefly images are modified in this way. The two examples here show a detail of the composition with the 'Glow' layer turned on and one with the layer turned off.

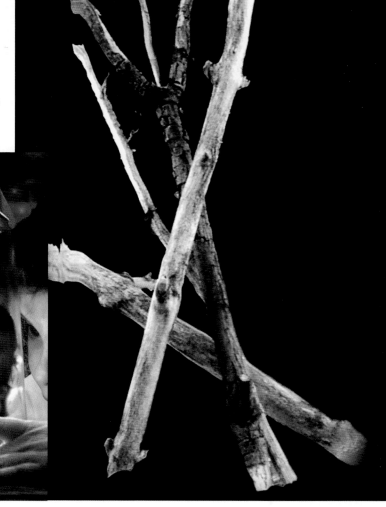

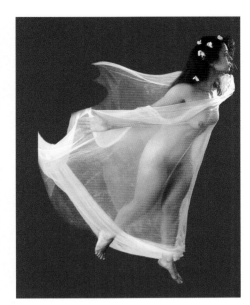

The model for the fairy image was photographed standing in the studio. A separate shot was then taken with her sitting side-saddle on a stool and her feet off the ground. The images of the legs and feet replaced the ones in the first photograph to give her the appearance of floating. The images for the wings were chosen from photographs taken of several different children's toys.

The finished element was positioned into the jar along with the images of the fireflies. A duplicate layer of the fairy was created, given a Gaussian blur at 15 pixels and placed below the original layer. The blurred layer was enlarged by about 10% using Free Transform and then brightened with Curves. The opacity of the original fairy layer was then reduced to 80% allowing the duplicate layer to show through. The result produces an image where the fairy appears to glow from within.

When all the elements were in place, color and tonal adjustments were made to bring all the images into consistency. Using Curves and Hue/Saturation, the image of the field was further altered, removing more color and density to lend the image an appearance of being far away and in a bit of haze. The white areas of the house were tinted blue and darkened while the reds and yellows in the foreground were brightened by reducing the of the amount of Cyan with the Selective Color command. One of our main objectives was to capture that special light, or "twilight" of summer. Based on the reaction we received, this task was achieved and the image has become a permanent part of our portfolio.

Marcolina Design

Marcolina Design Inc. was originally formed in 1990 by Daniel and Denise Marcolina. Since then Marcolina Design has grown from a partnership of two to a team of seven. Located in Conshohocken, Pennsylvania just west of Philadelphia on the banks of the Schuykill River, Marcolina Design in the early years concentrated their efforts in print and digital manipulated imagery. By utilizing the flexibility of the Macintosh, Marcolina Design quickly expanded into the field of interactive design, specializing in Web design, interactive CD-ROMs, as well as digital illustration, motion graphics and 2D and 3D animation. Their major clients have included Apple, A.T.&T., BF Goodrich Co., Kodak, and Sun Microsystems. Marcolina Design strongly believes that by keeping staff size small they are able to listen closely and respond quickly to their client's needs thus "molding complex possibilities into concrete solutions."

Measuring Relations
Photo CD

Bentley Institute
Bentley Systems: Cover art for a product service brochure

Motivate
Innovation Printing Inc.: Illustration

Kiss Me
Original work

Techno Love
Original work

Head of David
Sun Microsystems Inc.: Cover art for
brochure
Software: Collage

Business Wire Strip
Business Wire: Cover and inside cover for company brochure

Index of Artists

Russell Sparkman (pp. 128-131)

#D Seiwa Commons, 2-100
Issha, Meito-ku, Nagoya-shi
Aichi 465 Japan
052-703-6305
052-703-6986
sparkman@rspark.com

Sharon Steuer (pp. 116-119)

Bethany, CT 06524 USA
203-393-3981
wowartist@bigfoot.com
www.portfolios.com
/illustrators/steuer.sharon/

Michael Strassburger (pp. 88-91)

Modern Dog
7903 Greenwood Ave. NE
Seattle, WA 98103 USA
206-789-7667
206-789-3171
moddog@aol.com

Gordon Studer (pp. 106-115)

1576 62nd St.
Emeryville, CA 94608 USA
510-655-4256
510-655-4256
gstuder363@aol.com

Yukinori Tokoro (pp. 60-63)

Tokoro Photo Studio
4-9 Uguisudani-cho
Shibuya-ku, Tokyo 157 Japan
03-5489-2208
03-5489-3308
exit@ajbb.co.jp
www.ajbb.co.jp/tokoro/
tokoro.html

Richard Wolfströme (pp. 120-127)

The Art of Invention
Brighton Media Centre 9-12
Middle Street Brighton
East Sussex BN1 1AL UK
01273-384-234
01273-384-235
wolfi@the-art.co.uk
www.the-art.co.uk

Tadanori Yokoo (pp. 36-41)

4-19-7 Seijo, Setagaya-ku
Tokyo 157 Japan
03-3482-2826
03-3482-2451

143